Cool Restaurants
Miami

teNeues

Imprint

Editors:	Martin Nicholas Kunz, Katharina Feuer
Photos (location):	BGW Design Limited Inc. (Barton G.), courtesy Mandarin Oriental, Roland Bauer (Café Sambal), Jonathan Eismann (Pacific Time, food), Joseph Pessar (Prime 112, food) All other photos by Martin Nicholas Kunz & Katharina Feuer
Introduction:	Katharina Feuer
Layout:	Martin Nicholas Kunz
Imaging & Pre-press:	Jan Hausberg
Map:	go4media. – Verlagsbüro, Stuttgart
Translations:	SAW Communications, Dr. Sabine A. Werner, Mainz Céline Verschelde (French), Silvia Gomez de Antonio (Spanish), Elena Nobilini (Italian), Dr. Suzanne Kirkbright (English), Nina Hausberg (German / recipes)

Produced by fusion publishing GmbH, Stuttgart . Los Angeles
www.fusion-publishing.com

Published by teNeues Publishing Group

teNeues Publishing Company
16 West 22nd Street, New York, NY 10010, USA
Tel.: 001-212-627-9090, Fax: 001-212-627-9511

teNeues Book Division
Kaistraße 18, 40221 Düsseldorf, Germany
Tel.: 0049-(0)211-994597-0, Fax: 0049-(0)211-994597-40

teNeues Publishing UK Ltd.
P.O. Box 402, West Byfleet, KT14 7ZF, Great Britain
Tel.: 0044-1932-403509, Fax: 0044-1932-403514

teNeues France S.A.R.L.
4, rue de Valence, 75005 Paris, France
Tel.: 0033-1-55766205, Fax: 0033-1-55766419

teNeues Iberica S.L.
Pso. Juan de la Encina 2–48, Urb. Club de Campo
28700 S.S.R.R. Madrid, Spain
Tel./Fax: 0034-91-65 95 876

www.teneues.com

ISBN-10:	3-8327-9066-7
ISBN-13:	978-3-8327-9066-0

Bibliographic information published by
Die Deutsche Bibliothek. Die Deutsche Bibliothek lists
this publication in the Deutsche Nationalbibliografie;
detailed bibliographic data is available in the Internet
at http://dnb.ddb.de.

Contents

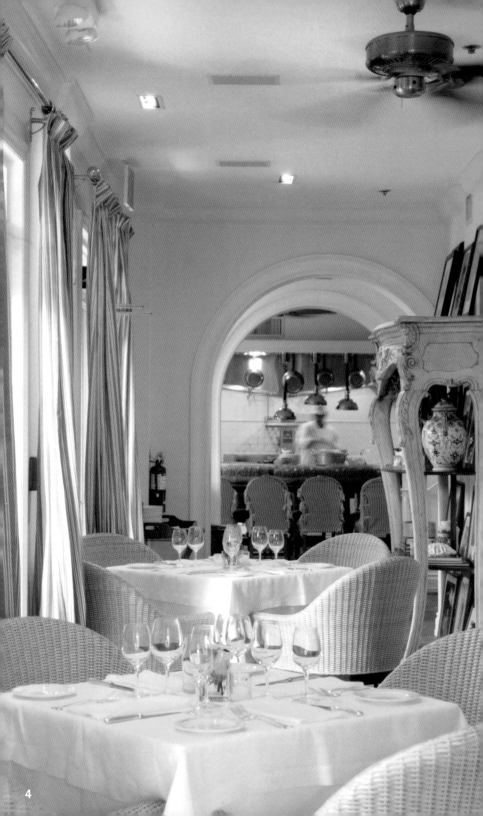

Introduction

Miami is increasingly developing into a real stronghold of gastronomic delight. No wonder—the subtropical metropolis has one of the world's longest beaches and is a playground for party-goers, the international jet-set and artists from around the globe. Here, at Florida's south-eastern tip, what counts most of all is multi-cultural relaxation and a great atmosphere. Sun, sea and sand not only influence the outfits of casual strollers and night owls, who are mainly scantily clad, but also the design of restaurants, bars and clubs. A lot happens outdoors; and the interiors are usually reminiscent of the set for a fashion shoot than restaurants and dance clubs. *Cool Restaurants Miami* introduces an exciting range of top addresses for all occasions—the Nikki Beach Club, in a dream beach location, with luxurious sun-loungers and white sun umbrellas and combining beach bar, restaurant and night-club, the Stephane Dupoux design for Touch and Tantra, a mix of restaurant and lounge, or even Casa Tua, designed in a very personal style by Michele Bonan and the owner, Michele Grendene. Traditional bars are also included, like The Forge, Pacific Time, Joe's Stone Crab and brand-new bars, such as Jacques Garcia's design for the restaurant VIX in Hotel Victor, or the Grass restaurant & lounge by young designer Maxime Dautresme in Miami's Design District.

But even in Miami where guests look as good as the design of the bars, it's not just a restaurant's image that takes center stage. Miami's cuisine is influenced by elements from the nearby Caribbean and Central America, which connect international chefs with a European, Asian, African and American flair. All this creates a unique mix of the exotic with a love of the experimental. In an area where everything is within easy reach, you can find world-class restaurants with famous star chefs like Frederic Colin at Raleigh Restaurant, Mark Militello at Mark's South Beach or Mike Sabin at Prime 112.

Katharina Feuer

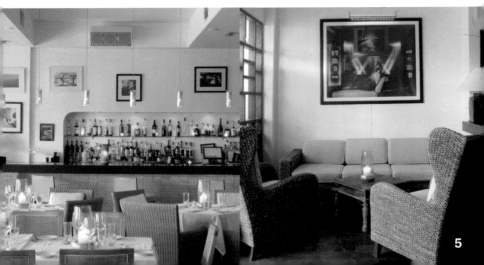

Einleitung

Miami entwickelt sich mehr und mehr zur gastronomischen Hochburg. Kein Wunder, denn die subtropische Metropole mit einem der größten Badestrände der Welt ist ein Tummelplatz für Partygänger, den Jetset und Kreative aus aller Welt. Hier an der Südostspitze Floridas herrscht mutlikulturelle Lockerheit und gute Stimmung. Sonne, Strand und Meer beeinflussen nicht nur das Outfit der Flaneure und Nachtschwärmer, das meist eher knapp ausfällt, sondern auch das Design der Restaurants, Bars und Clubs. Vieles findet unter freiem Himmel statt; die Innenräume erinnern meist eher an eine Kulisse für Modefotografie als an Restaurants und Tanzschuppen. *Cool Restaurants Miami* präsentiert eine spannende Auswahl der besten Adressen für alle Anlässe – den Nikki Beach Club, der – in traumhafter Strandlage gelegen – mit seinen riesigen Liegebetten und weißen Sonnenschirmen Strandbar, Restaurant und Nightclub in sich vereinigt, das vom Designer Stephane Dupoux gestaltete Touch und Tantra, das eine Kombination von Restaurant und Lounge ist oder auch die Casa Tua, die in einem sehr persönlichen Stil von Michele Bonan und dem Inhaber Michele Grendene entworfen wurde. Es zählen traditionsreiche Lokale dazu, wie The Forge, Pacific Time, Joe's Stone Crab und brandneue, wie das von Jacques Garcia gestaltete Restaurant VIX im Hotel Victor oder die Grass restaurant & lounge des jungen Designers Maxime Dautresme im Design District Miamis.

Doch auch in Miami, wo die Gäste so gut aussehen wie das Design der Lokalitäten, steht nicht nur die Optik der Restaurants im Vordergrund. Miamis Küche ist charakterisiert durch Einflüsse aus der nahe gelegenen Karibik und Mittelamerika, die internationale Küchenchefs mit europäischen, asiatischen, afrikanischen und amerikanischen Elementen verbinden. So entsteht eine unvergleichliche Kombination aus Exotik und Experimentierfreude. Auf überschaubarem Raum findet man Weltklasse Restaurants mit namhaften Spitzenköchen, wie Frederic Colin im Raleigh Restaurant, Mark Militello bei Mark's South Beach oder Mike Sabin im Prime 112.

Katharina Feuer

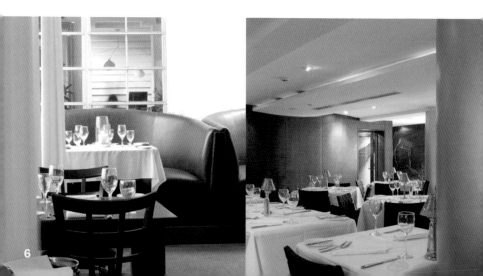

Introduction

Miami affirme de plus en plus son statut de citadelle gastronomique. Il n'est donc pas surprenant que la métropole subtropicale, qui offre l'une des plus grandes plages du monde, soit le rendez-vous des noctambules, des jet-setters et des créateurs du monde entier. Ici, à la pointe sud-est de la Floride, règnent une décontraction multiculturelle et une bonne ambiance. Le soleil, la plage et la mer influencent non seulement le style vestimentaire, généralement plutôt court, des promeneurs et des noctambules, mais également le design des restaurants, des bars et des clubs. De nombreuses manifestations ont lieu en plein air ; les pièces intérieures font plutôt penser la plupart du temps à une coulisse de photographie de mode qu'à des restaurants et des salles de danse. *Cool Restaurants Miami* présente une sélection passionnante des meilleures adresses pour toutes les occasions : le Nikki Beach Club qui, occupant une place de rêve au bord de la plage, réunit, avec ses grandes chaises longues et ses parasols blancs, bar de plage, restaurant et boîte de nuit ; le Touch, agencé par le designer Stephane Dupoux, et le Tantra qui associe restaurant et lounge ; le Casa Tua, conçu d'après le style très personnel de Michele Bonan et du propriétaire Michele Grendene. Viennent s'y ajouter des locaux riches en traditions, comme The Forge, Pacific Time, Joe's Stone Crab et des endroits plus récents comme le restaurant VIX aménagé par Jacques Garcia dans l'hôtel Victor ou le Grass restaurant & lounge du jeune designer Maxime Dautresme dans le Design District de Miami.

Toutefois à Miami, là où les clients ont une apparence aussi parfaite que le design des restaurants, ce n'est pas seulement l'optique des restaurants qui est au premier plan. Les chefs cuisiniers internationaux associent la cuisine de Miami, influencée par l'Amérique centrale et les Caraïbes situées tout près, à des éléments européens, asiatiques, africains et américains. Le mélange de l'exotisme et des expérimentations culinaires fait naître une combinaison unique. Dans cet espace dont on obtient une vue d'ensemble, on trouve des restaurants de classe mondiale avec d'excellents cuisiniers renommés comme Frederic Colin au Raleigh Restaurant, Mark Militello chez Mark's South Beach ou Mike Sabin au Prime 112.

Katharina Feuer

Introducción

Miami se está convirtiendo en un centro gastronómico, algo nada extraordinario teniendo en cuenta que esta metrópoli subtropical, con una de las playas más largas del mundo, es el lugar de encuentro de los amantes de la fiesta, de la jet set y de artistas. Aquí, en el extremo sureste de Florida, domina la distensión multicultural y el buen ambiente. El sol, la playa y el mar no sólo influyen sobre el atrevido modo de vestir de los paseantes y los amantes de la noche, sino también sobre el diseño de los bares, los restaurantes y los clubes. Casi todo transcurre al aire libre, mientras que los espacios interiores se asemejan más a un escenario para la fotografía de moda que a un restaurante o a una discoteca. *Cool Restaurants Miami* presenta una interesante selección de las mejores direcciones para cada ocasión: el Nikki Beach Club, un bar de playa, restaurante y club nocturno situado en una maravillosa playa y famoso por sus enormes tumbonas y sombrillas blancas, el Touch, una creación de Stephane Dupoux, el Tantra, que combina un restaurante con un salón, o la Casa Tua, diseñada en el estilo extremadamente personal de Michele Bonan y de su propietario Michele Grendene. También se incluyen locales llenos de tradición como The Forge, Pacific Time, Joe's Stone Crab, y otros completamente nuevos, como el restaurante VIX del Hotel Victor proyectado por Jacques Garcia o el Grass restaurant & lounge, situado en el Design District de Miami y obra del joven diseñador Maxime Dautresme.

Sin embargo, en Miami, donde los visitantes son tan atractivos como el diseño de los bares, la estética del restaurante no es lo único importante. La cocina de Miami se caracteriza por las influencias del cercano Caribe y de Centroamérica, que los chefs internacionales fusionan con elementos culinarios europeos, asiáticos, africanos y americanos creando de este modo una combinación única entre el exotismo y el placer por la experimentación. En un espacio abarcable encontramos restaurantes de reconocimiento mundial con famosos cocineros de primera categoría, como Frederic Colin en Raleigh Restaurant, Mark Militello en Mark's South Beach o Mike Sabin en Prime 112.

Katharina Feuer

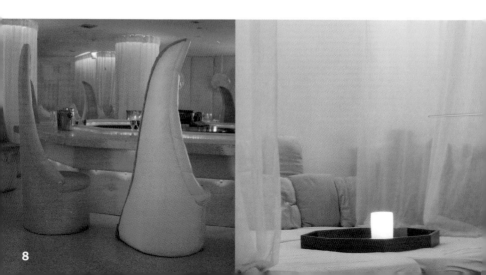

Introduzione

Miami sta diventando sempre più una roccaforte gastronomica. Non c'è da stupirsi: la metropoli subtropicale, con una delle spiagge balneari più grandi del mondo, è, infatti, un ritrovo per gli amanti di party, per il jet set e per gli estrosi di tutto il mondo. Qui, nella punta sudorientale della Florida, regna la rilassatezza multiculturale e il buon umore. Sole, spiaggia e mare influenzano non solo il look dei girandoloni e dei nottambuli, il più delle volte piuttosto succinto, ma anche il design di ristoranti, bar e club. Il cielo aperto fa da scenario a molti locali; gli ambienti interni ricordano spesso uno sfondo per fotografie di moda più che ristoranti e discoteche. *Cool Restaurants Miami* presenta una fantastica selezione degli indirizzi migliori per qualsiasi occasione: il Nikki Beach Club, situato in una splendida posizione sulla spiaggia, che, con i suoi giganteschi lettini e ombrelloni bianchi, è al contempo bar, ristorante e night club; il Touch, arredato dal designer Stephane Dupoux, il Tantra, una combinazione di ristorante e locale lounge, oppure anche il Casa Tua, progettato con stile del tutto personale da Michele Bonan e dal titolare Michele Grendene. Completano la selezione locali tradizionali, come per esempio The Forge, Pacific Time, Joe's Stone Crab, e locali nuovissimi, come il ristorante VIX arredato da Jacques Garcia nell'hotel Victor o il Grass restaurant & lounge del giovane designer Maxime Dautresme nel Design District di Miami.

Eppure anche a Miami, dove i frequentatori dei locali hanno un aspetto tanto bello quanto il design dei locali stessi, non è solo l'immagine dei ristoranti ad essere in primo piano. La cucina di Miami risente dell'influenza dei vicini Caraibi e dell'America centrale, a cui chef internazionali s'ispirano mescolandone le caratteristiche ad ingredienti europei, asiatici, africani e americani. Ne risulta un singolare mix di esotismo e voglia di sperimentare. Su uno spazio così contenuto si ritrovano ristoranti di gran classe con noti chef quali Frederic Colin al Raleigh Restaurant, Mark Militello al Mark's South Beach o Mike Sabin al Prime 112.

Katharina Feuer

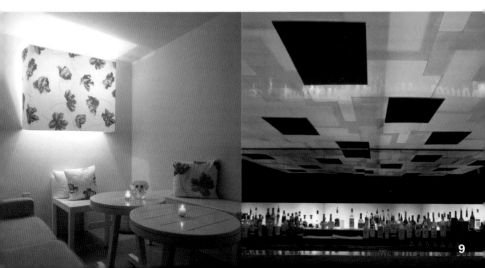

Barton G.

Design & Owner: Barton G. Weiss
Chef: Ted Mendez, Arthur Jones, Gerry Gnassi

1427 West Avenue | Miami, FL 33139 | South Beach
Phone: +1 305 672 8881
www.bartong.com
Opening hours: Sun–Thu 6 pm to 10 pm, Fri–Sat 6 pm to midnight
Average price: $ 40
Cuisine: American new
Special features: Special events, private and business parties

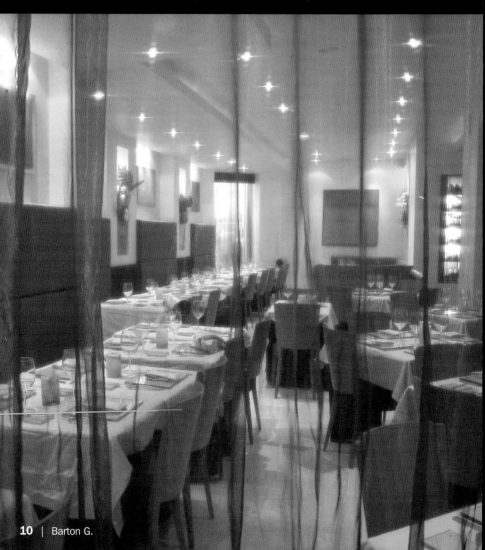

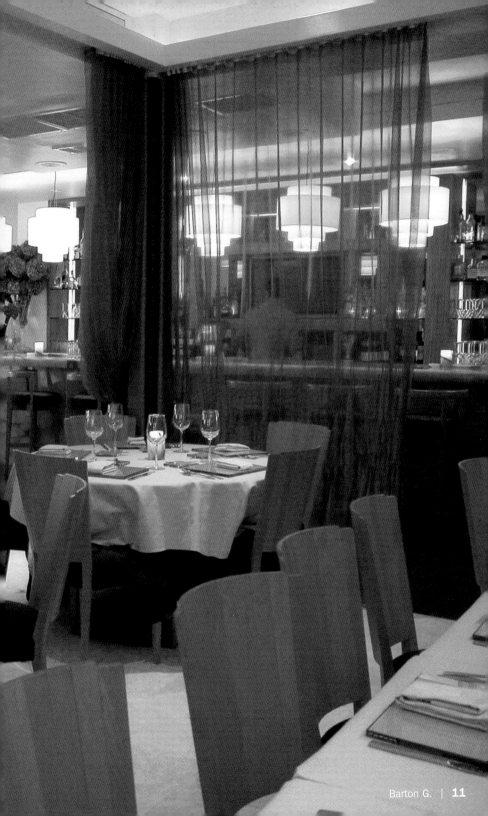

B.E.D. Miami
Beverage.Entertainment.Dining

Design: Oliver Hoyos | Chef: Vitor Casassola, Michael Yerks
Owners: Oliver Hoyos, Pascale Hoyos

929 Washington Avenue | Miami, FL 33139 | South Beach
Phone: +1 305 532 9070
www.bedmiami.com
Opening hours: Mon–Sun 8 pm to 5 am, dinner 8 pm to 11 pm
Average price: $ 35
Cuisine: Contemporary American-French with global influences
Special features: You are served dinner in bed

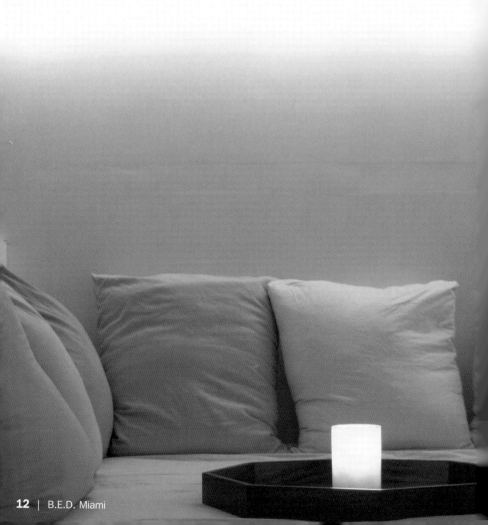

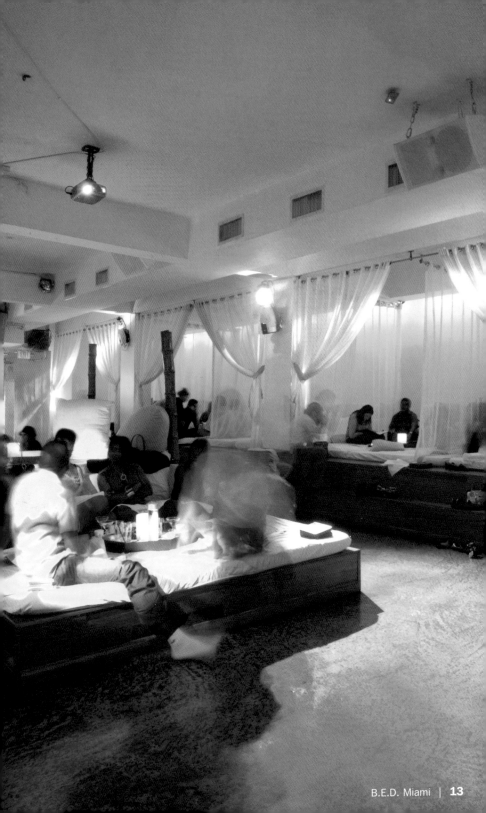

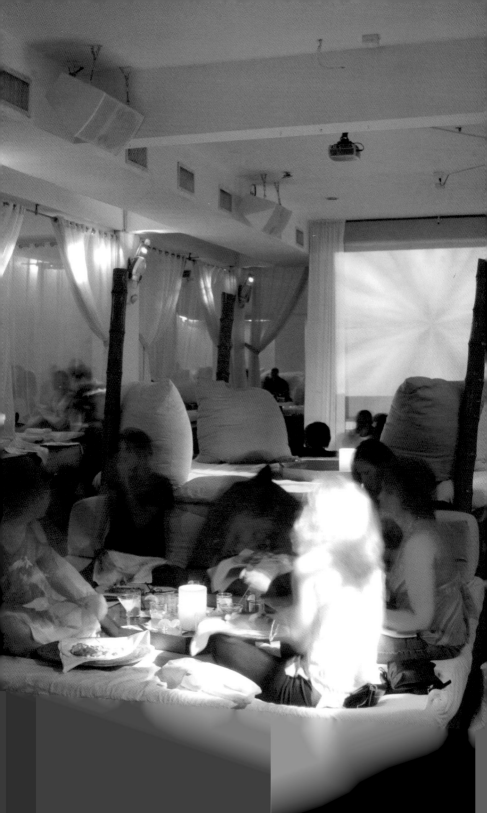

Lobster Santos

Hummer Santos
Homard Santos
Langosta Santos
Astice Santos

2 lobster tails

Sauce:
240 ml coconut milk
240 ml cream
4 tbsp ginger, grated
4 oz cashew nuts, roasted
1 lobster tail, cooked

1/2 fresh pineapple, in chunks
8 cherry tomatoes, halved
2 sticks celery, sliced
Salt, pepper
Chives

Bring coconut milk and cream to a boil. Purée ginger, cashew nuts and cooked lobster tail. Add the purée to coconut milk mixture. Add pineapple, tomatoes and celery to the sauce. Season with salt and pepper. Blanch the lobster tails for 1 minute in salted water, cut in half lengthways and finish cooking in the sauce. Spoon the pineapple chunks, celery and tomatoes onto the center of 4 plates. Top with halved lobster tail, pour the sauce over lobster and garnish with chives.

2 Hummerschwänze

Sauce:
240 ml Kokosnussmilch
240 ml Sahne
4 EL Ingwer, gerieben
120 g Cashnewnüsse, geröstet
1 Hummerschwanz, gekocht

1/2 frische Ananas, gewürfelt
8 Kirschtomaten, halbiert
2 Stangen Sellerie, in Scheiben
Salz, Pfeffer
Schnittlauch

Kokosnussmilch und Sahne aufkochen lassen. Ingwer, Nüsse und gekochten Hummerschwanz pürieren. Das Püree zu der Kokosnussmilchmischung geben. Ananas, Tomaten und Sellerie zu der Sauce geben. Mit Salz und Pfeffer würzen. Die Hummerschwänze für 1 Minute in gesalzenem Wasser blanchieren, der Länge nach zerteilen und in der Sauce zu Ende garen. Ananasstücke, Sellerie und Tomaten in die Mitte von 4 Tellern geben. Hummerhälfte darauflegen, Sauce darübergeben und mit Schnittlauch garnieren.

2 queues de homard

Sauce :
240 ml de lait de coco
240 ml de crème
4 c. à soupe de gingembre, râpé
120 g de noix de cajou, grillées
1 queue de homard, cuite

1/2 ananas frais, coupé en dés
8 tomates cerise, coupées en deux
2 branches de céleri, coupées en tranches
Sel, poivre
Ciboulette

Amener à ébullition le lait de coco et la crème. Réduire en purée le gingembre, les noix et la queue de homard cuite. Ajouter cette purée au mélange à base de lait de coco. Ajouter l'ananas, les tomates et le céleri à la sauce. Saler et poivrer. Blanchir les queues de homard pendant 1 minute dans de l'eau salée, les couper dans le sens de la longueur et les laisser mijoter dans la sauce jusqu'à ce qu'elles soient cuites. Disposer au centre de 4 assiettes les morceaux d'ananas, le céleri et les tomates. Poser sur chaque assiette une demi-queue de homard, verser la sauce et garnir de ciboulette.

2 colas de langosta

Salsa:
240 ml de leche de coco
240 ml de nata
4 cucharadas de jengibre, rallado
120 g de anacardos, tostados
1 cola de langosta, cocida

1/2 de piña fresca, en dados
8 tomates cereza, en mitades
2 ramas de apio, en rodajas
Sal, pimienta
Cebollino

Lleve la leche de coco y la nata a ebullición. Pase el jengibre, los anacardos y la cola cocida de langostino por el pasapurés. Incorpore el puré a la mezcla de leche de coco y nata. Añada la piña, los tomates y el apio a la salsa. Salpimiente. Escalde las colas de langostino durante 1 minuto en agua con sal. Córtelas después por la mitad longitudinalmente y continúe cociéndolas en la salsa hasta que estén hechas. Coloque los dados de piña, el apio, los tomates en el centro de cada uno de los 4 platos. Ponga encima una mitad de cada cola, vierta después la salsa por encima y decore con el cebollino.

2 code di astice

Salsa:
240 ml di latte di noce di cocco
240 ml di panna
4 cucchiai di zenzero grattugiato
120 g di anacardi tostati
1 coda di astice lessata

1/2 ananas fresco tagliato a dadini
8 pomodorini ciliegia divisi a metà
2 gambi di sedano a rondelle
Sale, pepe
Erba cipollina

Portate ad ebollizione il latte di cocco e la panna. Riducete in purea lo zenzero, gli anacardi e la coda di astice lessata e unite la purea al composto di latte di cocco. Aggiungete alla salsa l'ananas, i pomodorini e il sedano. Salate e pepate. Sbollentate le code di astice in acqua salata per 1 minuto, dividetele a metà nel senso della lunghezza e fatele finire di cuocere nella salsa. Al centro di 4 piatti mettete i pezzetti d'ananas, il sedano e i pomodorini. Sistematevi sopra le metà di astice, versatevi la salsa e guarnite con erba cipollina.

150 20th Street | Miami, FL 33139 | South Beach
Phone: +1 305 398 1806
www.townhousehotel.com
Opening hours: Every day 6 pm to midnight
Average Price: $ 30
Cuisine: Japanese, sushi
Special features: Oversized chairs, hot bartenders

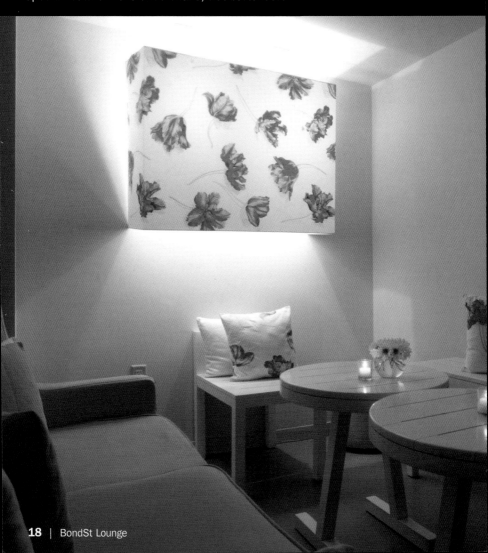

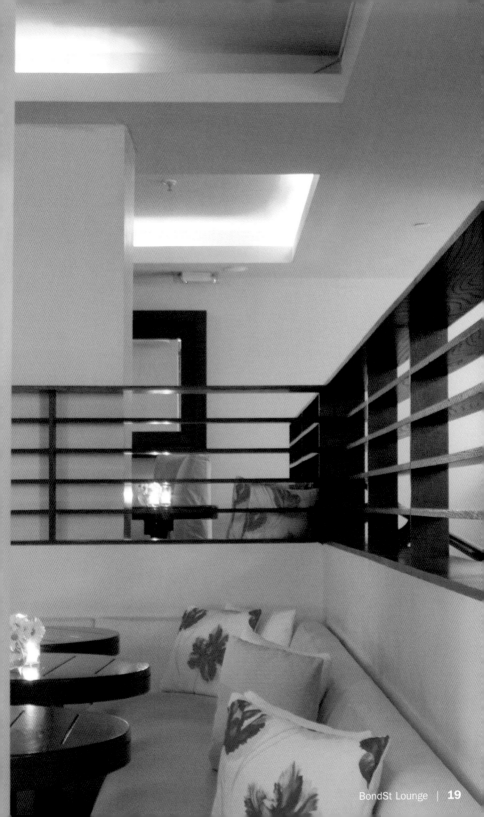

Sesame-crusted Shrimp Roll

Sesamummantelte Shrimpsrolle

Rouleaux de crevettes enveloppés de sésame

Rollitos de langostinos en camisa de sésamo

Rotolo di gamberi in mantello di sesamo

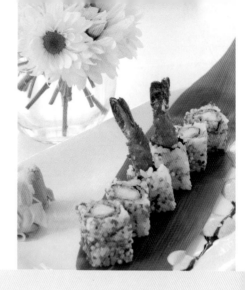

8 Black Tiger shrimps, shelled and cleaned
1 egg
Breadcrumbs
Oil for deep-frying

12 1/2 oz sushi rice, cooked and seasoned
4 leaves of nori (seaweed)
4 tbsp chives, chopped
2 tbsp sesame seeds

1 small onion, diced
1 tsp curry powder
6 tbsp orange juice
2 tbsp mayonnaise
Balsamic vinegar reduction

Coat the shrimps in egg and breadcrumbs and deep-fry for 2 minutes until golden brown. Remove tail pieces, take 2 fried shrimps and place tail to tail on a leaf of nori, which is coated with sushi rice. Roll up tight, until it resembles an angular shape and sprinkle the outside of roll with chopped chives and sesame seeds. Chill. For the sauce, combine onion, curry powder, orange juice and mayonnaise. Cut the shrimp roll into 6 pieces, garnish with the saved shrimp tails and serve with sauce. For decoration, drizzle the balsamic reduction over the curry sauce.

8 Black Tiger Shrimps, ausgelöst und geputzt
1 Ei
Paniermehl
Öl zum Frittieren

360 g Sushireis, gekocht und gewürzt
4 Blätter Nori (Seetang)
4 EL Schnittlauch, gehackt
2 EL Sesamkörner

1 kleine Zwiebel gewürfelt
1 TL Currypulver
6 EL Orangensaft
2 EL Mayonnaise
Aceto Balsamico, eingekocht

Shrimps in Ei und Paniermehl tauchen und 2 Minuten frittieren, bis sie goldbraun sind. Das Schwanzstück entfernen, 2 Shrimps nehmen und Ende an Ende auf ein Blatt Nori legen, das mit Sushireis bedeckt ist. Eng rollen, bis es eine eckige Form angenommen hat und die Außenseite mit gehacktem Schnittlauch und Sesamkörnern bestreuen. Kühlen. Für die Sauce die Zwiebel, Currypulver, Orangensaft und Mayonnaise mischen. Die Shrimpsrolle in 6 Stücke schneiden, mit den zurückbehaltenen Shrimpschwänzen garnieren und mit der Sauce servieren. Die Essigreduktion als Dekoration über die Currysauce träufeln.

8 crevettes black tiger, décortiquées et nettoyées
1 oeuf
Chapelure
De l'huile à frire

360 g de riz pour sushis, cuit et assaisonné
4 feuilles de nori (fucus)
4 c. à soupe de ciboulette, hachée
2 c. à soupe de graines de sésame

1 petit oignon coupé en dés
1 c. à café de poudre de curry
6 c. à soupe de jus d'orange
2 c. à soupe de mayonnaise
Vinaigre balsamique, réduit

Plonger les crevettes dans l'œuf et dans la chape-
lure et les faire frire pendant 2 minutes jusqu'à ce
qu'elles soient dorées. Couper la queue, prendre
2 crevettes et les placer bout à bout sur 1 feuille
de nori recouverte de riz pour sushis. Rouler en
serrant de façon à obtenir une forme carrée et
saupoudrer les cotés extérieurs de ciboulette et
de graines de sésame. Laisser refroidir. Pour la
sauce, mélanger les oignons, la poudre de curry,
le jus d'orange et la mayonnaise. Couper le rou-
leau de crevettes en 6 morceaux, garnir avec les
queues de crevettes restantes et servir avec la
sauce. Ajouter quelques gouttes de vinaigre pour
décorer la sauce au curry.

8 langostinos tigre negro, pelados y limpios
1 huevo
Pan rallado
Aceite para freír

360 g de arroz sushi, cocido y sazonado
4 hojas de alga nori
4 cucharadas de cebollino, picado
2 cucharadas de semillas de sésamo

1 cebolla pequeña, en dados
1 cucharadita de curry molido
6 cucharadas de zumo de naranja
2 cucharadas de mayonesa
Vinagre balsámico, reducido

Reboce los langostinos en el huevo y el pan
rallado y fríalos durante 2 minutos hasta que
estén dorados. Deseche los extremos de las
colas. Coja 2 langostinos y colóquelos sobre
una hoja de nori unidos por las colas. Enrolle los
langostinos apretando la hoja hasta conseguir
una forma angulosa. Esparza la cara exterior con
el cebollino y las semillas de sésamo. Déjelos
enfriar. Para preparar la salsa mezcle la cebolla,
el curry, el zumo de naranja y la mayonesa. Corte
los rollitos de langostino en 6 trozos, adórnelos
con las colas y sirva con la salsa. Utilice el aceite
reducido para decorar. Viértalo por encima de la
salsa de curry.

8 gamberi tipo Black Tiger sgusciati e puliti
1 uovo
Pangrattato
Olio per friggere

360 g di riso per sushi lessato e condito
4 fogli di nori (alga)
4 cucchiai di erba cipollina tritata
2 cucchiai di semi di sesamo

1 cipolla piccola tagliata a dadini
1 cucchiaino di polvere di curry
6 cucchiai di succo d'arancia
2 cucchiai di maionese
Aceto balsamico ridotto

Passate i gamberi nell'uovo e nel pangrattato e
friggeteli per 2 minuti finché saranno ben dorati.
Private i gamberi della coda. Su un foglio di nori
ricoperto di riso mettete 2 gamberi in modo tale
che le loro estremità si tocchino. Formate un
rotolo ben stretto dandogli una forma squadrata
e cospargete il lato esterno con erba cipollina
tritata e semi di sesamo. Fate raffreddare. Per la
salsa mescolate la cipolla, la polvere di curry, il
succo d'arancia e la maionese. Tagliate il rotolo
di gamberi in 6 pezzi, guarnite con le code di
gamberi tenute da parte e servite con la salsa.
Per decorare, versate sulla salsa al curry alcune
gocce di aceto ridotto.

Café Sambal

Design: Tony Chi, www.tonychi.com
Chef: Tom Parlo, Paul Miller

500 Brickell Key Drive | Miami, FL 33131 | Brickell Key
Phone: +1 305 913 8251
www.mandarinoriental.com
Opening hours: Every day 6:30 am to 11 pm
Average price: $ 60
Cuisine: Asian
Special features: Casual waterfront restaurant

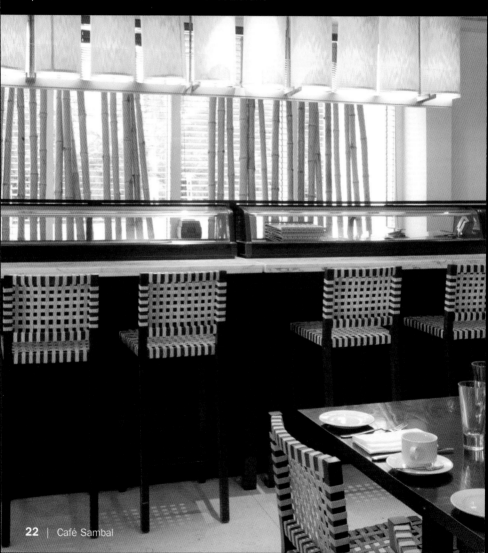

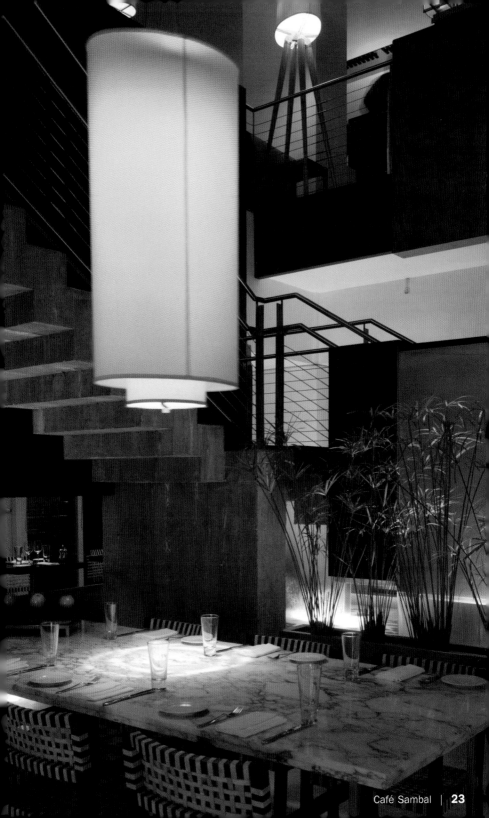

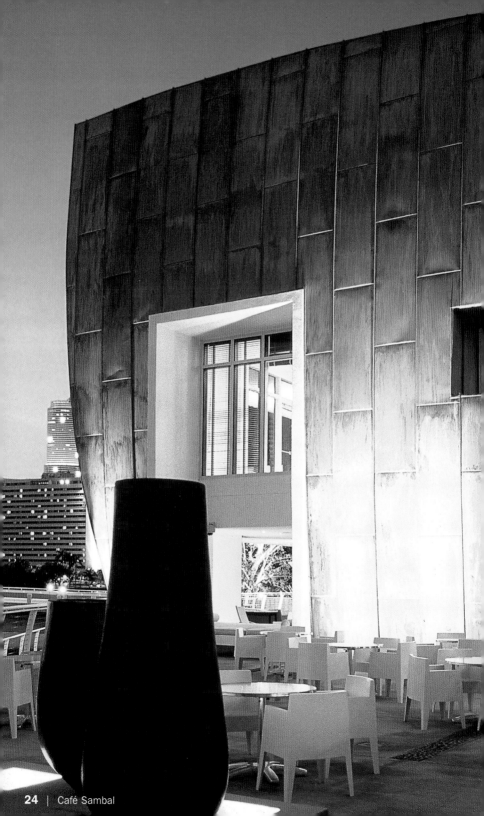

Casa Tua

Design: Michele Bonan | Chef: Sergio Sigala
Owner: Michele Grendene

1700 James Avenue | Miami, FL 33139 | South Beach
Phone: +1 305 673 1010
www.casatualifestyle.com
Opening hours: Lunch Mon–Fri 11:30 am to 3 pm, dinner Mon–Sun 6:30 pm
to midnight
Average price: $ 37
Cuisine: Innovative Italian
Special features: Very private atmosphere, chic country Italian-style establishment

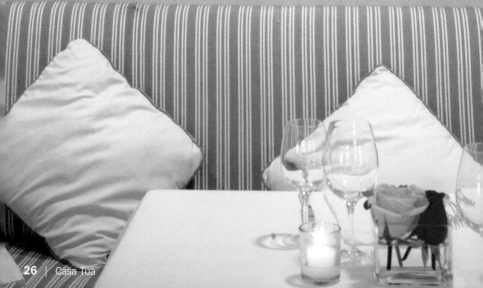

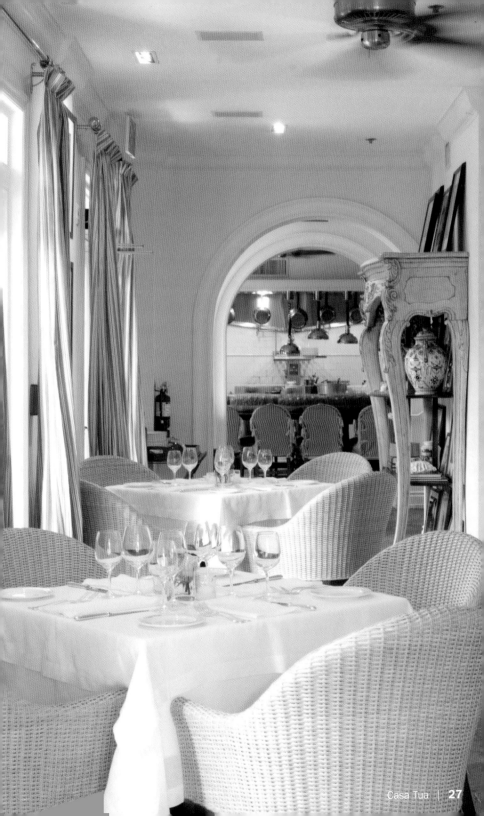

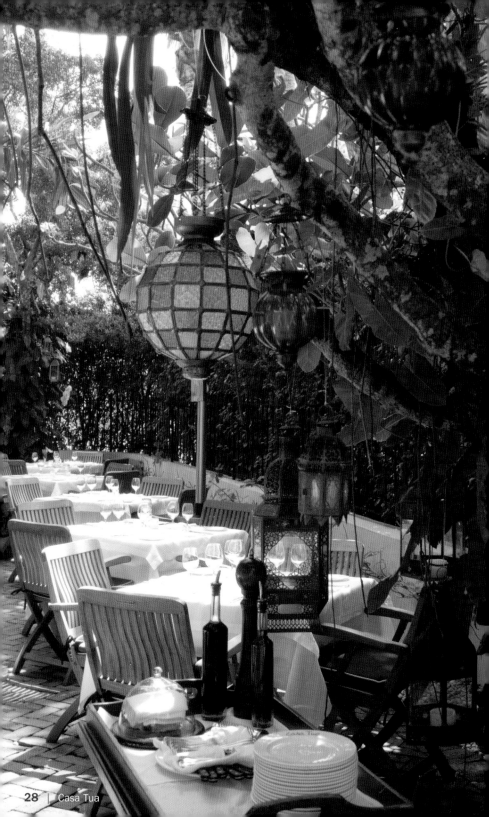

Roasted
Lamb Cutlets
with Sautéd Fennel

Gebratene Lammkoteletts mit sautiertem Fenchel

Carré d'agneau grillé au fenouil sauté

Chuletas de cordero asadas con hinojo salteado

Costolette di agnello al forno con finocchio saltato

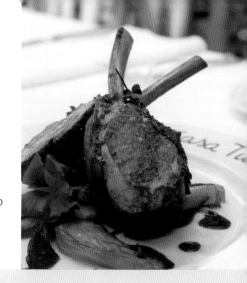

8 lamb cutlets, as 1 cut of meat
Salt, pepper
4 tbsp olive oil
2 fennel, each cut into 8 slices
2 whole cloves of garlic
1 red chili, chopped
1 tsp cumin
1 tsp powdered fennel seeds
1 tsp cardamom powder

Remove fat from the lamb cutlets, leaving the meat on the bone. Season the lamb with salt, pepper and 2 tbsp olive oil, then roast in a pre-heated oven at 390 °F for approx. 15 minutes. Heat 2 tbsp olive oil in a frying pan, add the sliced fennel, garlic and chili, season with salt and pepper and sauté until tender. Remove the lamb cutlets from the oven and cover the meat with a mix of cumin powder, fennel seed powder and cardamom powder. Allow the cutlets to stand for about 10 minutes in a warm place (e.g. in a covered pot). Divide the cutlets into 8 pieces and combine the lamb juices with the fennel liquid in a small pot. Arrange on each plate 4 slices of fennel, top with 2 lamb cutlets and drizzle with the reserved liquid.

8 Lammkoteletts, am Stück
Salz, Pfeffer
4 EL Olivenöl
2 Fenchel, jeweils in 8 Scheiben geschnitten
2 Knoblauchzehen, ganz
1 rote Chilischote, gehackt
1 TL Cuminpulver
1 TL Fenchelsamenpulver
1 TL Kardamompulver

Die Fettseite des Lamms entfernen, den Knochen drinlassen. Das Lamm mit Salz, Pfeffer und 2 EL Olivenöl würzen, dann in einem vorgeheizten Ofen bei 200 °C für ca. 15 Minuten braten. 2 EL Olivenöl in einer Pfanne erhitzen, den Fenchel, Knoblauch und Chili zugeben, mit Salz und Pfeffer würzen und sautieren bis sie weich sind. Die Lammkoteletts aus dem Ofen nehmen und das Fleisch mit einem Mix aus Cuminpulver, Fenchelsamenpulver und Kardamompulver bedecken. Die Koteletts für ca. 10 Minuten an einem warmen Ort (z.B. einem abgedeckten Topf) ruhen lassen. Das Kotelettstück in 8 Teile teilen und die Lammsäfte mit der Fenchelflüssigkeit in einen kleinen Topf geben. Pro Teller 4 Scheiben Fenchel und 2 Lammkoteletts anrichten und mit der zurückbehaltenen Flüssigkeit beträufeln.

Un carré de 8 côtelettes d'agneau
Sel, poivre
4 c. à soupe d'huile d'olive
2 fenouils, chacun coupé en 8 tranches
2 gousses d'ail, entières
1 piment rouge haché
1 c. à café de poudre de cumin
1 c. à café de poudre de graines de fenouil
1 c. à café de poudre de cardamome

Désosser l'agneau en gardant l'os pour la cuisson. Assaisonner l'agneau avec le sel, le poivre et deux cuillères à soupe d'huile d'olive, puis le faire griller dans un four préchauffé à 200 °C pendant environ 15 minutes. Faire chauffer 2 cuillères à soupe d'huile d'olive dans une poêle, ajouter le fenouil, l'ail et le piment rouge, saler et poivrer et faire revenir jusqu'à ce qu'ils soient tendres. Retirer le carré d'agneau du four et recouvrir la viande d'un mélange de poudre de cumin, poudre de graines de fenouil et de poudre de cardamome. Laisser reposer le carré pendant environ 10 minutes à un endroit chaud (par ex. dans une casserole fermée). Diviser le carré en 8 parts et verser les sucs de la viande dans une petite casserole avec le jus du fenouil. Disposer sur chaque assiette 4 tranches de fenouil et 2 côtelettes d'agneau et arroser avec la sauce mise de côté.

8 chuletas de cordero, en un trozo
Sal, pimienta
4 cucharadas de aceite de oliva
2 hinojos, cada uno cortado en 8 rodajas
2 dientes de ajo, enteros
1 guindilla roja, picada
1 cucharadita de comino molido
1 cucharadita de semillas de hinojo, molidas
1 cucharadita de cardamomo, molido

Deseche el lado de la grasa del cordero dejando el hueso. Sazone la carne con sal, pimienta y 2 cucharadas de aceite de oliva. Ase el cordero en un horno precalentado a 200 °C durante aproximadamente 15 minutos. Caliente 2 cucharadas de aceite de oliva en una sartén, incorpore el hinojo, el ajo y la guindilla, salpimiente y saltee los ingredientes hasta que estén blandos. Saque las chuletas de cordero del horno y cubra la carne con una mezcla de comino, semillas de hinojo y cardamomo molidos. Deje reposar la carne durante 10 minutos aproximadamente en un lugar caliente (p.ej. en una cazuela tapada). Corte la carne en 8 porciones. Vierta el jugo de la carne y del hinojo en una cazuela. Ponga en cada plato 4 rodajas de hinojo y 2 chuletas de cordero. Vierta por encima los jugos.

8 costolette di agnello in un pezzo unico
Sale, pepe
4 cucchiai di olio d'oliva
2 finocchi, ciascuno tagliato in 8 spicchi
2 spicchi d'aglio interi
1 peperoncino rosso tritato
1 cucchiaino di cumino in polvere
1 cucchiaino di semi di finocchio in polvere
1 cucchiaino di cardamomo in polvere

Eliminate la parte di grasso dell'agnello lasciando l'osso. Condite l'agnello con sale, pepe e 2 cucchiai di olio d'oliva, passatelo in forno preriscaldato a 200 °C per ca. 15 minuti. In una padella scaldate 2 cucchiai di olio d'oliva, aggiungete il finocchio, l'aglio e il peperoncino, salate e pepate e fate saltare il tutto finché sarà appassito. Togliete le costolette dal forno e cospargete la carne con una miscela di cumino, semi di finocchio e cardamomo in polvere. Lasciate riposare le costolette per ca. 10 minuti in un luogo caldo (ad es. in una pentola chiusa). Tagliate il carré di costolette in 8 pezzi, in una pentola piccola mettete il fondo di cottura dell'agnello con il liquido di cottura del finocchio. Mettete su ogni piatto 4 spicchi di finocchio e 2 costolette di agnello e versatevi alcune gocce del liquido di cottura tenuto da parte.

Grass restaurant & lounge

Design: Maxime Dautresme, Alain & Nicole Suissa
Chef: Pedro Duarte | Owners: Alain & Nicole Suissa

28 NE 40 Street | Miami, FL 33137 | Design District
Phone: +1 305 573 3355
www.grasslounge.com
Opening hours: Tue–Sat 8 pm to 5 am, closed Sun–Mon
Average price: $ 25
Cuisine: Pan Asian, Caribbean
Special features: Lounge and nightclub, live DJ

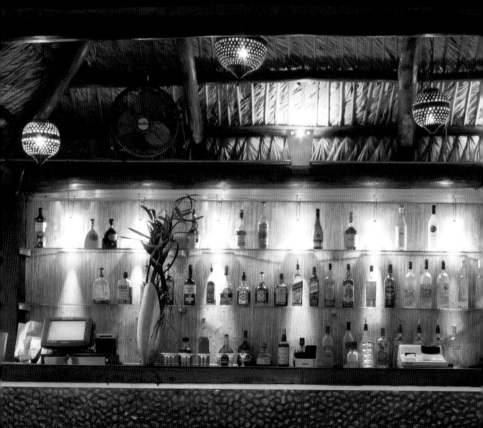

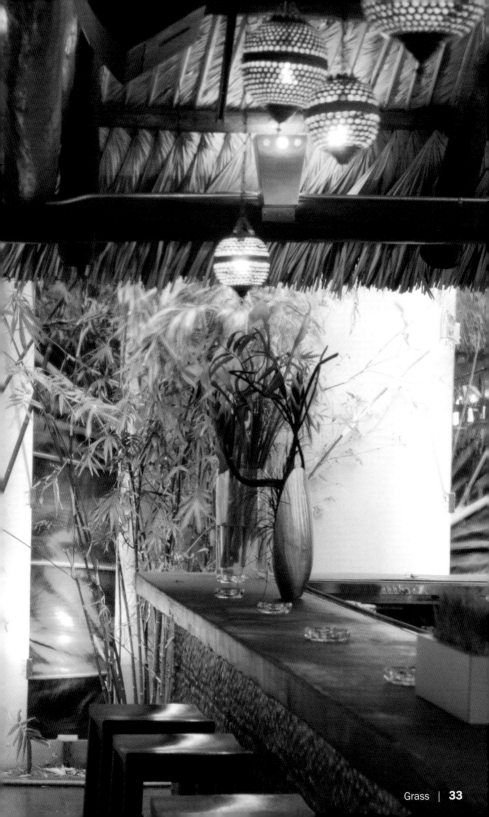

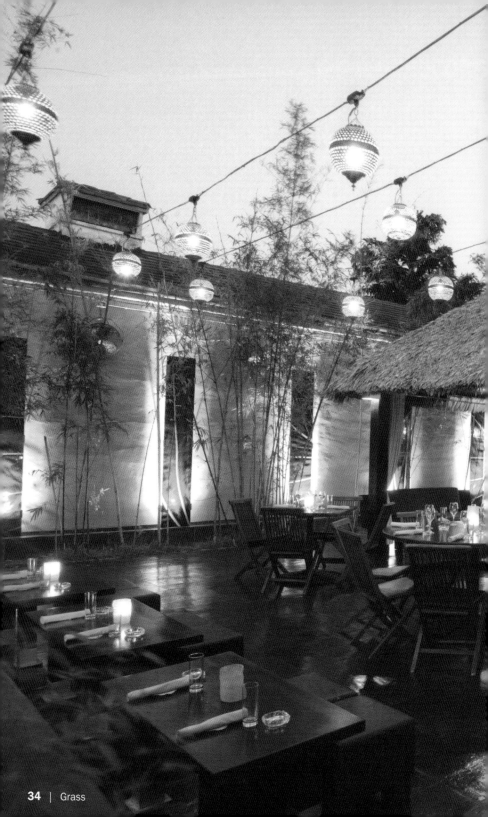

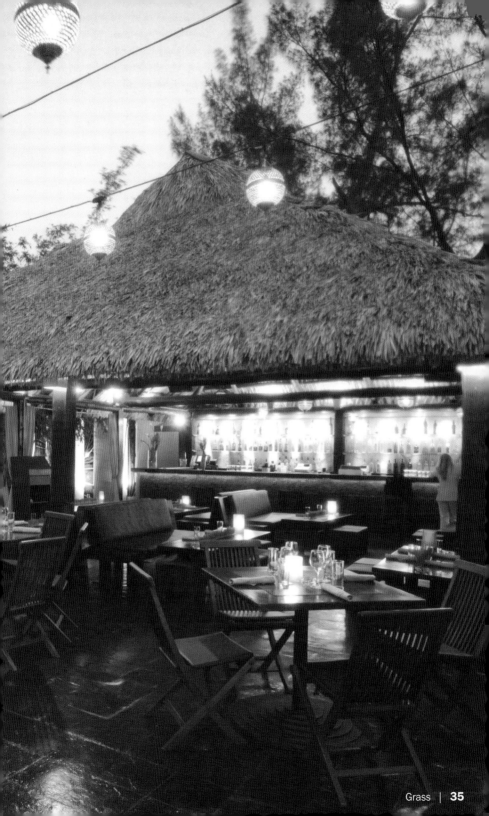

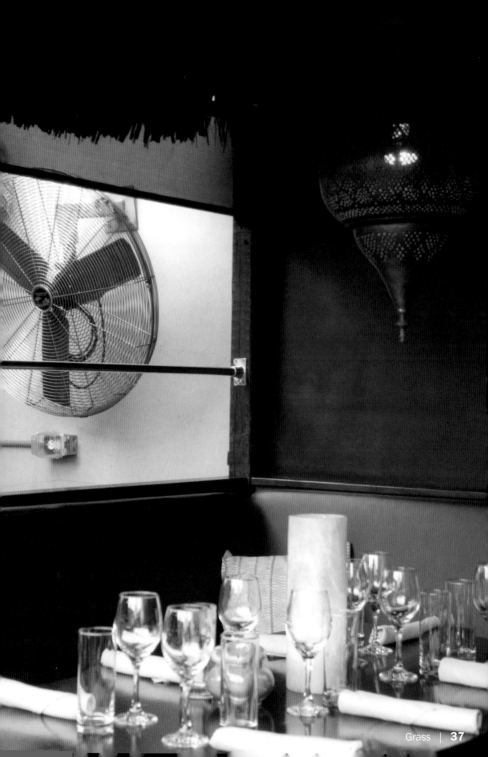

Joe's Stone Crab

Owner: Steve Sawitz

11 Washington Avenue | Miami, FL 33139 | South Beach
Phone: +1 305 673 0365
www.joesstonecrab.com
Opening hours: October 15th to may 15th; every day lunch 11:30 am to 2 pm,
dinner Mon–Thu 5 pm to 10 pm, Fri–Sat 5 pm to 11 pm, Sun 4 pm to 10 pm
Average price: Appetizers from $ 7, entrees from $ 11
Cuisine: Seafood
Special features: Established 1913, old tradition, legendary restaurant, take-away,
direct shipping

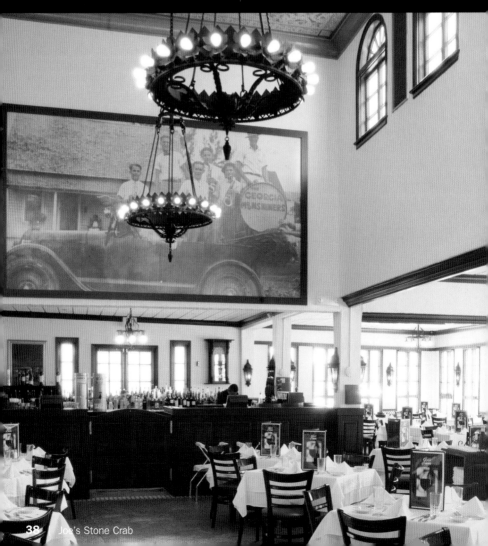

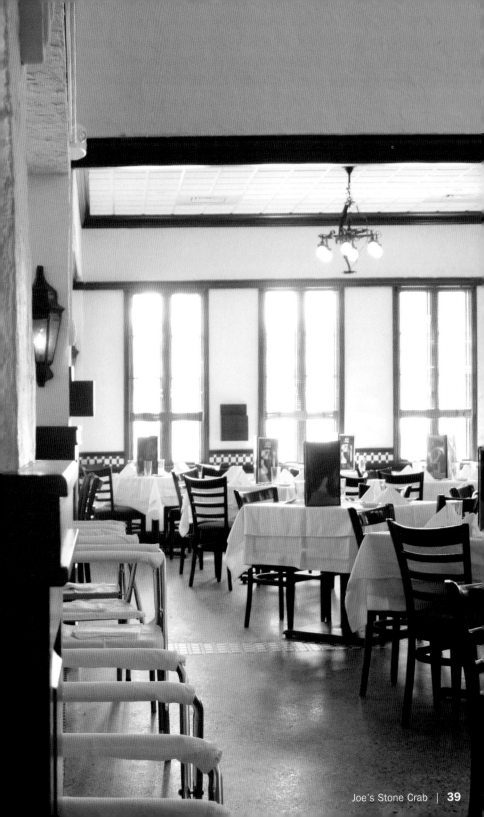

Joe's
Hash Browns

Joe's Hash Browns
Joe's Hash Browns
Patatas a lo pobre de Joe
Joe's Hash Browns

3 pounds potatoes
5 tbsp vegetable oil
Salt, pepper

Peel the potatoes and cut in half lengthways.
Cook in boiling salted water. Drain and cool. Cut
the potatoes into thin, irregular pieces.

Heat 2 tbsp oil in a non-stick skillet over a medi-
um heat. When the oil is hot, add the potatoes
and season with salt and pepper. Fry for approx.
15 minutes, until the edges start to brown. Turn
the potatoes over with a wooden spoon. Add
more oil if necessary and season again with
salt and pepper. Sauté for another 15 minutes,
adjusting the heat to prevent burning. When the
hash browns have a nice golden color on both
sides, place on a kitchen towel to remove excess
oil. Serve hot with crab meat.

1,5 kg festkochende Kartoffeln
5 EL Pflanzenöl
Salz, Pfeffer

Kartoffeln schälen und der Länge nach halbieren.
In kochendem Salzwasser garen. Abgießen und
abkühlen lassen. Anschließend in dünne, unre-
gelmäßige Stücke schneiden.

2 EL Öl in einer beschichteten Pfanne bei mitt-
lerer Hitze erwärmen. Wenn das Öl heiß ist, die
Kartoffeln hineingeben und mit Salz und Pfeffer
würzen. Für ca. 15 Minuten braten lassen, bis
die Ränder anfangen zu bräunen. Mit einem
Holzlöffel die Kartoffeln wenden. Falls nötig, mehr
Öl hinzufügen und nochmals mit Salz und Pfeffer
würzen. Für weitere 15 Minuten braten, dabei die
Hitze anpassen, um Anbrennen zu verhindern.
Wenn die Hash Browns auf beiden Seiten eine
goldbraune Farbe haben, auf einem Küchentuch
das überschüssige Öl abtropfen lassen. Heiß mit
Krabbenfleisch servieren.

1,5 kg de pommes de terre fermes
5 c. à soupe d'huile végétale
Sel, poivre

Eplucher les pommes de terre et les couper en deux dans le sens de la longueur. Les faire cuire dans de l'eau salée bouillante. Verser l'eau et laisser refroidir. Couper ensuite en longs morceaux fins.

Faire chauffer 2 cuillères à soupe d'huile dans une poêle antiadhésive à feu moyen. Lorsque l'huile est chaude, ajouter les pommes de terre, puis saler et poivrer. Laisser frire pendant 15 minutes jusqu'à ce que les bords commencent à dorer. Retourner les pommes de terre à l'aide d'une cuillère en bois. Si nécessaire, rajouter huile, sel et poivre. Laisser de nouveau frire pendant 15 minutes, adapter la température pour éviter qu'elles ne brûlent. Lorsque les hash browns sont dorés des deux côtés, les poser sur une feuille d'essuie-tout pour absorber l'huile. Servir chaud avec de la viande de crabe.

1,5 kg de patatas para hervir
5 cucharadas de aceite vegetal
Sal, pimienta

Pele las patatas y córtelas por la mitad longitudinalmente. Cuézalas en agua con sal hirviendo. Vierta el agua y deje que se enfríen. Córtelas después en finos trozos irregulares.

Caliente a fuego medio 2 cucharadas de aceite en una sartén antiadherente. Cuando el aceite esté caliente, añada las patatas y salpimiente. Fríalas durante 15 minutos hasta que los bordes empiecen a dorarse. Dé la vuelta a las patatas empleando una cucharada de madera. Si es necesario añada más aceite y salpimiente nuevamente. Fría durante 15 minutos más ajustando el fuego para evitar que se quemen. Cuando las patatas estén doradas escúrralas sobre papel de cocina para eliminar el aceite sobrante. Sírvalas calientes con carne de cangrejo.

1,5 kg di patate sode
5 cucchiai di olio vegetale
Sale, pepe

Pelate le patate e tagliatele in due per il lungo. Fatele cuocere in acqua salata bollente. Scolatele e lasciatele raffreddare. Tagliatele quindi a pezzi sottili e irregolari.

In una padella antiaderente riscaldate 2 cucchiai di olio su fuoco medio. Quando l'olio sarà bollente, versatevi le patate, salate e pepate. Lasciate cuocere per ca. 15 minuti finché i contorni cominceranno a dorarsi. Girate le patate con un cucchiaio di legno. Se necessario, aggiungete altro olio e salate e pepate di nuovo. Fate cuocere per altri 15 minuti, regolando il calore per evitare di far attaccare le patate. Quando le Hash Browns avranno assunto da entrambi i lati un colore ben dorato, fate sgocciolare l'olio in eccesso su carta assorbente da cucina. Servite ancora bollenti con polpa di gamberetti.

Joia

Design: Sharon Lewis | Chef: Dago Riseco | Owner: Billy Espy

150 Ocean Drive | Miami, FL 33139 | South Beach
Phone: +1 305 674 8871
www.joiamiami.com
Opening hours: Sun–Wed 7 pm to 11:30 pm, Thu 7 pm to midnight, Fri–Sun 7 pm to 1 am
Average price: $ 45
Cuisine: World cuisine
Special features: Covered open air terrace, upper lounge with VIP

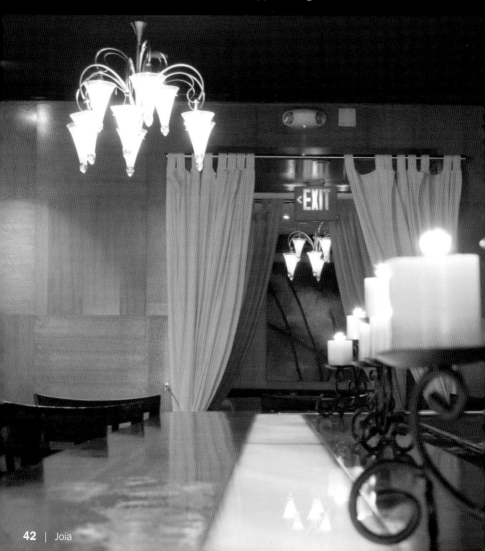

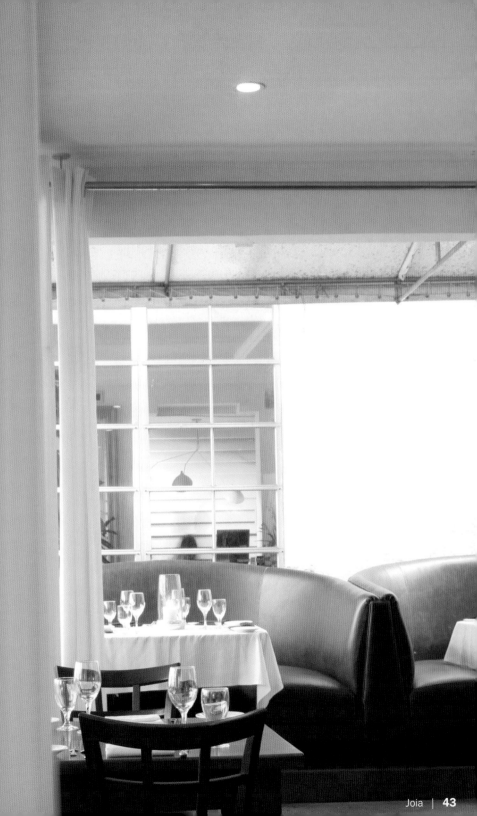

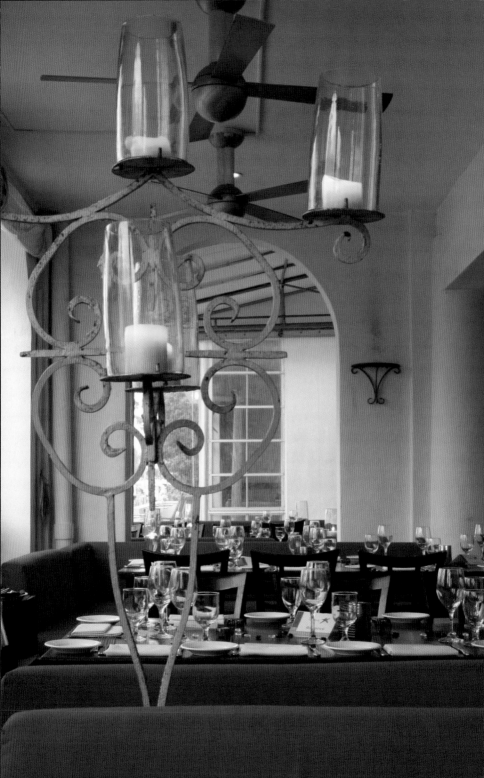

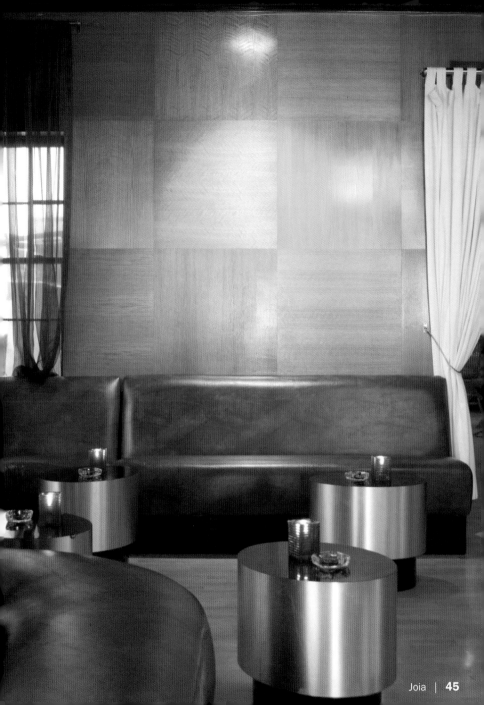

Macaluso's

Design, Chef & Owner: Michael Vito d'Andrea

1747 Alton Road | Miami, FL 33139 | South Beach
Phone: +1 305 604 1811
Opening hours: Tue–Sun 6 pm to midnight, Mon closed
Average price: $ 37
Cuisine: Homemade Italian food
Special features: Famous meatballs

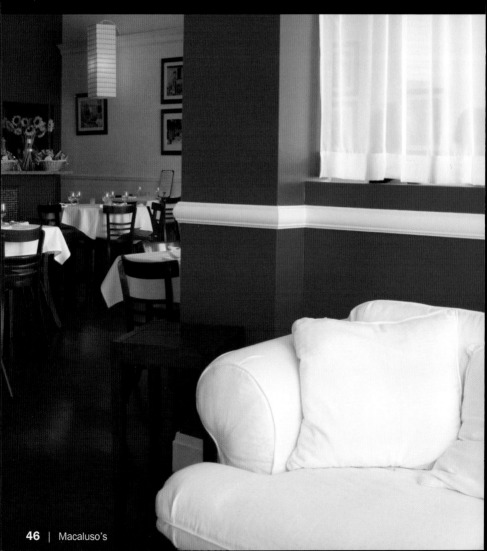

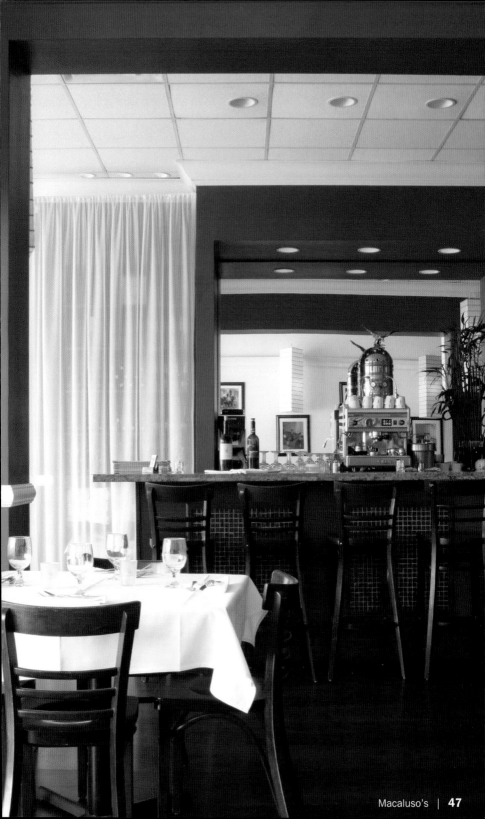

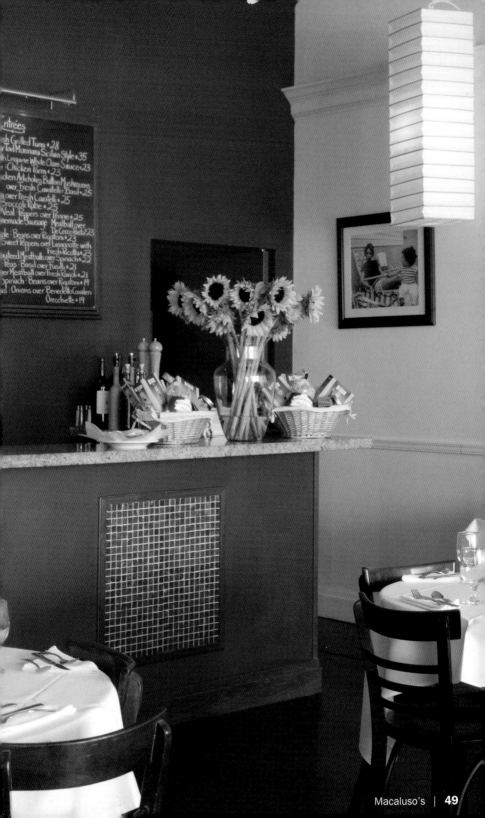

Mark's South Beach

Design: Peter Page | Chef & Owner: Mark Militello
Executive Chef: Larry LaValley

1120 Collins Avenue | Miami, FL 33139 | South Beach
Phone: +1 305 604 9050
www.chefmark.com
Opening hours: Lunch Mon–Sat noon to 3 pm, brunch Sun noon to 3 pm,
dinner every night 7 pm to 11 pm
Average price: $ 32
Cuisine: American
Special features: Private dining, poolside seating, bar-tasting menu

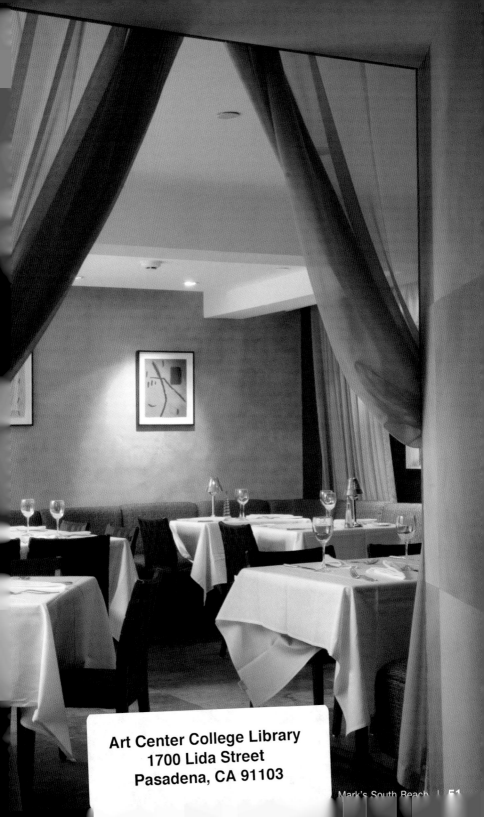

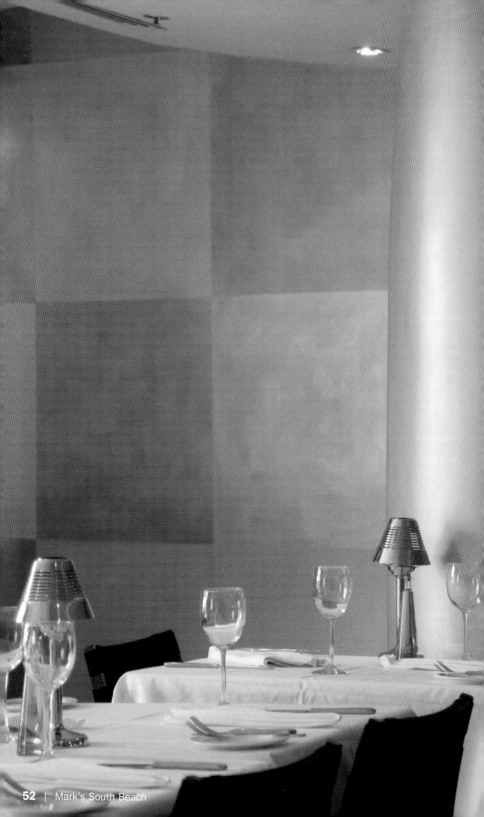

Fresh Conch
with Spicy Black Bean Salad

Frische Trompetenschnecke mit würzigem Schwarze-Bohnen-Salat

Buccins frais à la salade de haricots noirs

Caracoles trompeta frescos con sabrosa ensalada de judías negras

Tritone fresco con insalata piccante di fagioli neri

5 oz dried black beans
1 clove of garlic
1 red pepper, finely chopped
1 mango, peeled and finely diced
3 green onions, thinly sliced
1/2 habanero chili, seeded and chopped
3 tbsp olive oil
2 tbsp lime juice
1 tbsp fresh coriander, chopped
1 tbsp fresh mint, chopped
Salt, pepper, sugar

4 shelled conchs
Salt, pepper
2 eggs, beaten
60 ml milk
8 1/2 oz flour
8 1/2 oz breadcrumbs
Butter for frying

The day before, cover the beans with cold water and soak overnight. Place in a pot with garlic, cover with water and bring to a boil. Simmer until tender. Drain and rinse with cold water. Place in a bowl, add the remaining ingredients and season to taste. Cut the conch diagonally into 1/4 inch slices. Place between sheets of plastic wrap and using a meat tenderizer, pound the meat as thinly as possible. (Conch is very tough!) Season with salt and pepper. In a bowl, whisk the eggs and milk. Just before serving, heat the butter in a pan. Coat the conch first with the flour, then with the egg-milk mixture and finally with breadcrumbs. Fry in hot butter until golden brown. Place 3 tbsp bean salad in the center of a plate, arrange 3 slices of conch around it.

150 g getrocknete schwarze Bohnen
1 Knoblauchzehe
1 rote Paprikaschote, fein gehackt
1 Mango, geschält und fein gewürfelt
3 grüne Zwiebeln, in feinen Scheiben
1/2 Habanero-Chilischote, entkernt, gehackt
3 EL Olivenöl
2 EL Limettensaft
1 EL frischer Koriander, gehackt
1 EL frische Minze, gehackt
Salz, Pfeffer, Zucker

4 ausgelöste Trompetenschnecken
Salz, Pfeffer
2 Eier, verquirlt
60 ml Milch
240 g Mehl
240 g Paniermehl
Butter zum Braten

Am Vortag die Bohnen mit kaltem Wasser bedecken und über Nacht einweichen lassen. In einen Topf mit dem Knoblauch geben, mit Wasser bedecken und aufkochen lassen. Köcheln bis sie weich sind. Abgießen und mit kaltem Wasser abspülen. In eine Schüssel geben, die restlichen Zutaten zugeben und abschmecken. Die Schnecken diagonal in ca. 6 mm dicke Scheiben schneiden. Zwischen Plastikfolie legen und mit einem Fleischklopfer so dünn wie möglich ausklopfen. (Die Schnecken sind sehr zäh!) Mit Salz und Pfeffer würzen. In einer Schüssel die Eier und Milch verrühren. Kurz vor dem Servieren die Butter in einer Pfanne erhitzen. Die Schnecken erst in Mehl, dann in die Eiermilch und zum Schluss in das Paniermehl tauchen. In der heißen Butter braten, bis sie braun sind. 3 EL Bohnensalat in die Mitte des Tellers geben, 3 Scheiben Schnecke darum verteilen.

150 g de haricots noirs séchés
1 gousse d'ail
1 poivron rouge, haché finement
1 mangue, épluchée et coupée finement en dés
3 oignons verts, en tranches fines
$1/2$ piment habanero, dénoyauté, haché
3 c. à soupe d'huile d'olive
2 c. à soupe de jus de citron vert
1 c. à soupe de coriandre fraîche, hachée
1 c. à soupe de menthe fraîche, hachée
Sel, poivre, sucre

4 buccins décortiqués
Sel, poivre
2 œufs, battus
60 ml de lait
240 g de farine
240 g de chapelure
Du beurre à frire

La veille, recouvrir les haricots d'eau froide et lais-ser tremper pendant la nuit. Le lendemain, mettre les haricots et la gousse d'ail dans une casserole, recouvrir d'eau et amener à ébullition. Laisser bouillir à petite ébullition jusqu'à ce que les aliments soient tendres. Jeter l'eau et rincer à l'eau froide. Egoutter et mettre dans un récipient, ajouter les ingrédients restants et assaisonner. Couper les buccins en dia-gonale en morceaux d'environ 6 mm d'épaisseur. Les enrouler dans un film plastique et les aplatir à l'aide d'un attendrisseur aussi fins que possible. (Les buccins sont très durs !) Saler et poivrer. Mélanger dans un récipient les oeufs et le lait. Juste avant de servir, faire chauffer le beurre dans une poêle. Plonger en premier les buccins dans la farine, puis dans les œufs et le lait battus ensemble et enfin dans la chapelure. Les faire rissoler dans le beurre chaud jusqu'à ce qu'ils soient dorés. Disposer au centre de l'assiette 3 cuillères à soupe de salade de haricots, placer autour 3 tranches de buccins.

150 g de judías negras secas
1 diente de ajo
1 pimiento rojo, finamente picado
1 mango, pelado y cortado en finos dados
3 cebollas verdes, en finas rodajas
$1/2$ de guindilla habanero, despepitada, picada
3 cucharadas de aceite de oliva
2 cucharadas de zumo de lima
1 cucharadas de cilantro fresco, picado
1 cucharadas de menta fresca, picada
Sal, pimienta, azúcar

4 caracoles trompeta sin caparazón
Sal, pimienta
2 huevos, batidos
60 ml de leche
240 g de harina
240 g de pan rallado
Mantequilla para freír

El día anterior sumerja las judías en agua y déjelas en remojo durante la noche. Póngalas después en una cazuela con el ajo, cúbralas con agua y hiérvalas. Deje que cuezan hasta que estén blandas. Vierta el agua y límpielas con agua fría. Traspáselas a un cuenco, incorpore los demás ingredientes y sazone al gusto. Corte los caracoles diagonalmente en rodajas de aprox. 6 mm de grosor. Envuélvalas en film transparente y golpéelas con un martillo de cocina hasta que estén muy finas. (¡Los caracoles son muy tier-nos!). Salpimiente. Bata en un cuenco los huevos con la leche. Ante de servir caliente la mantequi-lla en una sartén. Reboce los caracoles en la hari-na, después en la leche con huevo y finalmente en el pan rallado. Fría la carne en la mantequilla caliente hasta que se dore. Ponga 3 cucharadas de la ensalada de judías en el centro de cada plato y coloque 3 rodajas de carne alrededor.

150 g di fagioli neri secchi
1 spicchio d'aglio
1 peperone rosso tritato finemente
1 mango sbucciato e tagliato a dadini piccoli
3 cipolle verdi a rondelle
$1/2$ peperoncino habanero tritato e senza semini
3 cucchiai di olio d'oliva
2 cucchiai di succo di limetta
1 cucchiaio di coriandolo fresco tritato
1 cucchiaio di menta fresca tritata
Sale, pepe, zucchero

4 tritoni sgusciati
Sale, pepe
2 uova sbattute
60 ml di latte
240 g di farina
240 g di pangrattato
Burro per friggere

La sera prima immergete i fagioli in acqua fredda e fateli rinvenire tutta la notte. Metteteli quindi in una pentola con l'aglio, ricoprite d'acqua e portate ad ebollizione. Lasciateli crogiolare fin-ché saranno teneri. Scolateli e sciacquateli con acqua fredda. Metteteli in una ciotola, unite gli ingredienti restanti e correggete di sapore. Tagliate i tritoni diagonalmente a fette di ca. 6 mm di spessore. Metteteli tra la pellicola traspa-rente e schiacciateli il più sottile possibile con un batticarne (i tritoni sono molto duri!). Salate e pepate. In una ciotola mescolate le uova e il latte. Poco prima di servire, scaldate il burro in una padella. Passate i tritoni nella farina, nel composto di uova e latte e infine nel pangrattato. Friggeteli nel burro bollente fino a dorarli. Mettete 3 cucchiai d'insalata di fagioli al centro del piatto e disponete intorno 3 fette di tritone.

Maroosh

Design: Samir al-Barq, Taquatchel & Ass.
Chef & Owner: Samir al-Barq

223 Valencia Avenue | Miami, FL 33134 | Coral Gables
Phone: +1 305 476 9800
www.maroosh.com
Opening hours: Tue–Sun 11:30 am to 10 pm, closed Mon
Average price: $ 35
Cuisine: Mediterranean, Middle Eastern, Lebanese
Special features: Exotic belly-dancing shows, original works of mid-east art

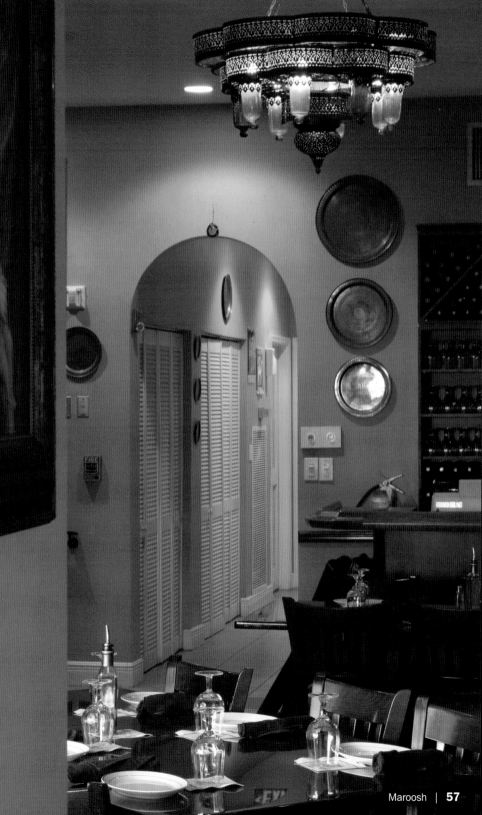

Lamb Cutlets
with Jumbo Prawns

Lammkoteletts mit Riesengarnelen
Côtelettes d'agneau aux crevettes géantes
Chuletas de cordero con cigalas gigantes
Costolette di agnello con gamberoni

8 lamb cutlets
Salt, pepper
Coriander

16 jumbo prawns, shelled
2 cloves of garlic, chopped
1 tbsp lemon juice
Pepper
2 tbsp olive oil

Side dishes:
Rice
Vegetables (broccoli, tomatoes, etc.)
Lemon slices and parsley for decoration

Sprinkle the meat with coriander, salt and pepper. Season the prawns with garlic and pepper and drizzle with lemon juice. Grill the meat and prawns over an open griddle until medium-rare. Serve with rice and vegetables and garnish with lemon wedges and parsley.

8 Lammkoteletts
Salz, Pfeffer
Koriander

16 Riesengarnelen, ausgelöst
2 Knoblauchzehen, gehackt
1 EL Zitronensaft
Pfeffer
2 EL Olivenöl

Beilagen:
Reis
Gemüse (Brokkoli, Tomaten etc.)
Zitronenschnitze und Petersilie für die Dekoration

Das Fleisch mit Koriander, Salz und Pfeffer bestreuen, die Garnelen mit Knoblauch und Pfeffer würzen und mit Zitronensaft beträufeln. Beides auf offener Flamme medium grillen. Mit Reis und Gemüse servieren und mit Zitronenschnitzen und Petersilie garnieren.

8 côtelettes d'agneau
Sel, poivre
Coriandre

16 crevettes géantes, décortiquées
2 gousses d'ail, hachées
1 c. à soupe de jus de citron
Poivre
2 c. à soupe d'huile d'olive

Accompagnement :
Riz
Légumes (brocolis, tomates, etc.)
Quartiers de citron et persil pour la décoration

Saupoudrer la viande de coriandre, de sel, et de poivre, assaisonner les crevettes avec l'ail et le poivre et arroser de jus de citron. Faire griller les deux sur la flamme vive pour obtenir une cuisson médium. Servir avec du riz et des légumes et garnir avec les quartiers de citron et le persil.

8 chuletas de cordero
Sal, pimienta
Cilantro

16 cigalas gigantes, peladas
2 dientes de ajo, picados
1 cucharada de zumo de limón
Pimienta
2 cucharadas de aceite de oliva

Acompañamientos:
Arroz
Verdura (brécol, tomates, etc.)
Tiras de piel de limón y perejil, para decorar

Sazone la carne con el cilantro, la sal y la pimienta, condimente las cigalas con el ajo y la pimienta y vierta por encima el zumo de limón. Ase a la parrilla a llama libre la carne y las cigalas hasta que estén medio hechas. Sirva con arroz y verdura y decore con las tiras de limón y el perejil.

8 costolette di agnello
Sale, pepe
Coriandolo

16 gamberoni sgusciati
2 spicchi d'aglio tritati
1 cucchiaio di succo di limone
Pepe
2 cucchiai di olio d'oliva

Contorni:
Riso
Verdura (broccoli, pomodori, ecc.)
Spicchi di limone e prezzemolo per decorare

Cospargete la carne con coriandolo, sale e pepe, condite i gamberoni con l'aglio e il pepe e versatevi alcune gocce di succo di limone. Grigliate sia la carne che il pesce sulla fiamma libera fino a media cottura. Servite con riso e verdura e guarnite con spicchi di limone e prezzemolo.

Design: Sam Robin, www.samrobin.com | Chef: Michael Rodriguez,
Mike Neal | Owners: Karim Masri, Nicola Siervo

956 Washington Avenue | Miami, FL 33139 | South Beach
Phone: +1 305 672 7217
www.metrokitchenbar.com
Opening hours: Sun–Mon, Wed–Thu 7 pm to 11 pm, Tue 7 pm to 12:30 am,
Fri–Sat 7 pm to midnight
Average price: $ 30
Cuisine: Modern American, with French, Italian and Asian influences
Special features: Indoor and outdoor seating

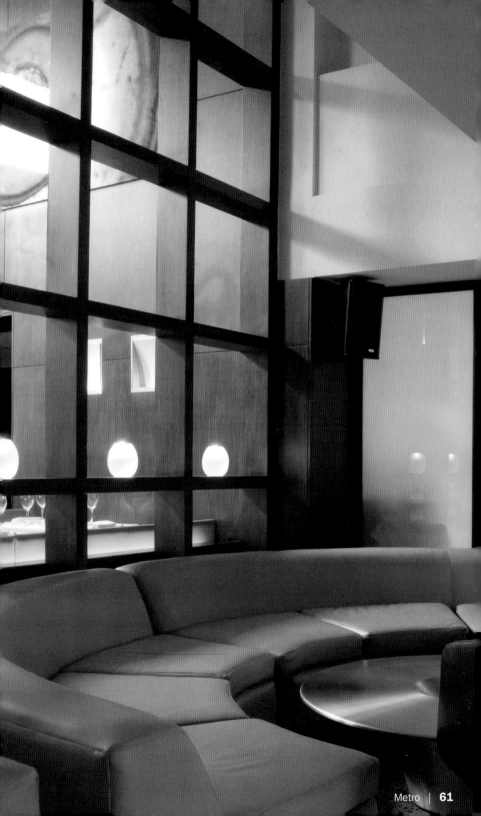

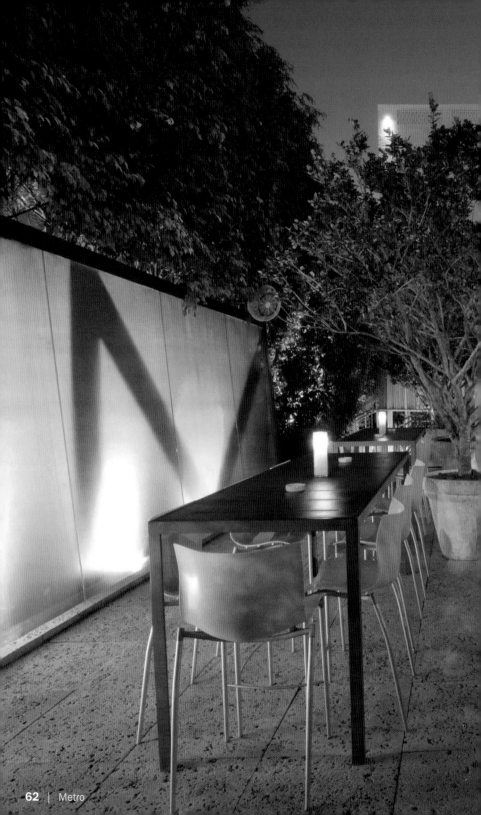

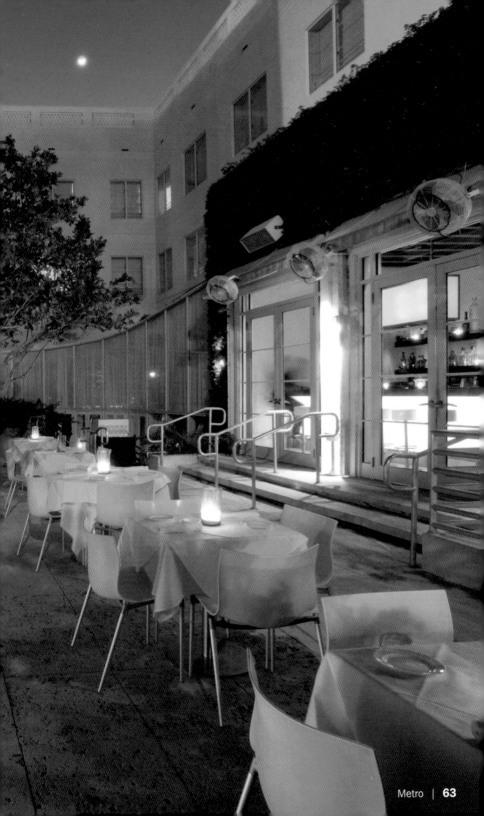

Mahi Mahi

with Tomato-Cucumber Salsa

Mahi Mahi mit Tomaten-Gurken-Salsa

Mahi mahi à la salsa de tomates et de concombres

Mahi Mahi con salsa de tomate y pepino

Mahi mahi con salsa di pomodori e cetrioli

4 Mahi Mahi filets (seabream), 6 oz each
2 tbsp black pepper
2 cinnamon sticks
2 tbsp coriander seeds
2 tbsp dried cumin
1 tsp nutmeg
5 cloves
2 spring onions
1 bunch fresh coriander
1 Scotch Bonnet Chili, chopped
5 cloves of garlic
Juice of 3 limes
2 tbsp molasses
4 oz brown sugar
4 oz dried thyme

Toast all the dry ingredients (not the sugar or thyme) and grind in a blender. Add the fresh ingredients, sugar and thyme. Blend well.

Place the Mahi Mahi filets in the marinade. Refrigerate.

4 tomatoes, diced
2 cucumbers, diced
1 red onion, diced
1 bunch coriander, chopped
1 clove of garlic, chopped
Juice of 2 limes
90 ml red-wine vinegar
Salt, pepper

Combine all the ingredients and season with salt and pepper. Refrigerate.

Fry the marinated filets in hot olive oil for approx. 7–10 minutes. Place the salsa in the middle of a plate and top with Mahi Mahi filet.

4 Mahi-Mahi-Filets (Dorade), je 180 g
2 EL schwarzer Pfeffer
2 Zimtstangen
2 EL Koriandersamen
2 EL getrockneter Kreuzkümmel
1 TL Muskat
5 Nelken
2 Frühlingszwiebeln
1 Bund frischer Koriander
1 Scotch-Bonnet-Chilischote, gehackt
5 Knoblauchzehen
Saft von 3 Limetten
2 EL Molasse
120 g brauner Zucker
120 g getrockneter Thymian

Alle trockenen Zutaten (außer dem Zucker und dem Thymian) rösten und in einem Mixer mahlen. Die frischen Zutaten, den Zucker und Thymian

zufügen. Gut mixen. Die Mahi-Mahi-Filets in die Marinade geben. Kalt stellen.

4 Tomaten, gewürfelt
2 Gurken, gewürfelt
1 rote Zwiebel, gewürfelt
1 Bund Koriander, gehackt
1 Knoblauchzehe, gehackt
Saft von 2 Limetten
90 ml Rotweinessig
Salz, Pfeffer

Alle Zutaten mischen und mit Salz und Pfeffer würzen. Kalt stellen.

Die marinierten Filets in heißem Olivenöl für ca. 7–10 Minuten braten. Die Salsa in die Mitte des Tellers geben und das Mahi Mahi Filet darauflegen.

4 filets de mahi mahi (dorade), de 180 g chacun
2 c. à soupe de poivre noir
2 bâtons de cannelle
2 c. à soupe de graines de coriandre
2 c. à soupe de cumin romain séché
1 c. à café de muscade
5 clous de girofle
2 petits oignons grelots
1 bouquet de coriandre fraîche
1 piment Scotch Bonnet, haché
5 gousses d'ail
Le jus de 3 citrons verts
2 c. à soupe de mélasse
120 g de sucre brun
120 g de thym séché

Faire griller tous les ingrédients secs (sauf le sucre et le thym) et moudre dans un mixer. Ajouter les ingrédients frais, le sucre et le thym.

Bien mixer. Mettre les filets de mahi mahi dans la marinade. Mettre au frais.

4 tomates, coupées en dés
2 concombres, coupés en dés
1 oignon rouge, coupé en dés
1 bouquet de coriandre, haché
1 gousse d'ail, hachée
Le jus de 2 citrons verts
90 ml de vinaigre de vin rouge
Sel, poivre

Mélanger tous les ingrédients, saler et poivrer. Mettre au frais.

Faire frire les filets marinés dans de l'huile d'olive chaude pendant 7–10 minutes. Disposer la salsa au centre de l'assiette et placer le filet de mahi mahi par-dessus.

4 filetes Mahi Mahi (dorada), cada uno de 180 g
2 cucharadas de pimienta negra
2 ramas de canela
2 cucharadas de semillas de cilantro
2 cucharadas de comino seco
1 cucharadita de nuez moscada
5 clavos
2 cebolletas
1 manojo de cilantro fresco
1 guindilla Scotch Bonnet, picada
5 dientes de ajo
Zumo de 3 limas
2 cucharadas de melaza
120 g azúcar moreno
120 g de tomillo seco

Saltee todos los ingredientes secos excepto el azúcar y el tomillo y tritúrelos en una batidora. Añada los ingredientes frescos, el azúcar y el

tomillo. Mezcle bien. Introduzca los filetes Mahi Mahi en la marinada. Reserve en el frigorífico.

4 tomates, en dados
2 pepinos, en dados
1 cebolla roja, en dados
1 manojo de cilantro, picado
1 diente de ajo, picado
Zumo de 2 limas
90 ml de vinagre de vino tinto
Sal, pimineta

Mezcle todos los ingredientes y salpimiente. Reserve en un lugar frío.

Fría los filetes marinados en aceite de oliva caliente entre 7–10 minutos. Ponga la salsa en el centro de cada plato y coloque encima los filetes Mahi Mahi.

4 filetti di mahi mahi (orata) da 180 g l'uno
2 cucchiai di pepe nero
2 bastoncini di cannella
2 cucchiai di semi di coriandolo
2 cucchiai di cumino essiccato
1 cucchiaino di noce moscata
5 chiodi di garofano
2 cipollotti
1 mazzetto di coriandolo fresco
1 peperoncino scotch bonnet tritato
5 spicchi d'aglio
Succo di 3 limette
2 cucchiai di molassa
120 g di zucchero di canna
120 g di timo essiccato

Fate tostare tutti gli ingredienti secchi (tranne lo zucchero e il timo) e macinateli in un frullatore. Aggiungete gli ingredienti freschi, lo zucchero e il

timo. Frullate bene. Mettete i filetti di mahi mahi nella marinata. Mettete a raffreddare.

4 pomodori tagliati a dadini
2 cetrioli tagliati a dadini
1 cipolla rossa tagliata a dadini
1 mazzetto di coriandolo tritato
1 spicchio d'aglio tritato
Succo di 2 limette
90 ml di aceto di vino rosso
Sale, pepe

Mescolate tutti gli ingredienti, salateli e pepateli. Mettete a raffreddare.

Friggete i filetti marinati nell'olio bollente per ca. 7–10 minuti. Mettete la salsa al centro di ogni piatto e sistematevi sopra un filetto di mahi mahi.

Miss Yip

Design: Paul Niski, Good Inc | Chef: Vincent Cheng
Owners: Jennie Yip, Amir Ben-Zion

1661 Meridian Avenue | Miami, FL 33139 | South Beach
Phone: +1 305 534 5488
www.missyipchinesecafe.com
Opening hours: Sun–Thu noon to 11 pm, Fri–Sat noon to midnight
Average price: $ 14
Cuisine: Traditional Chinese
Special features: Chinese mini market, Miss Yip tea collection, take out

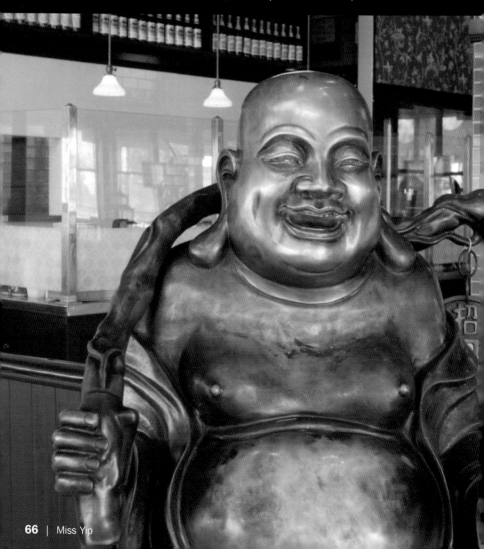

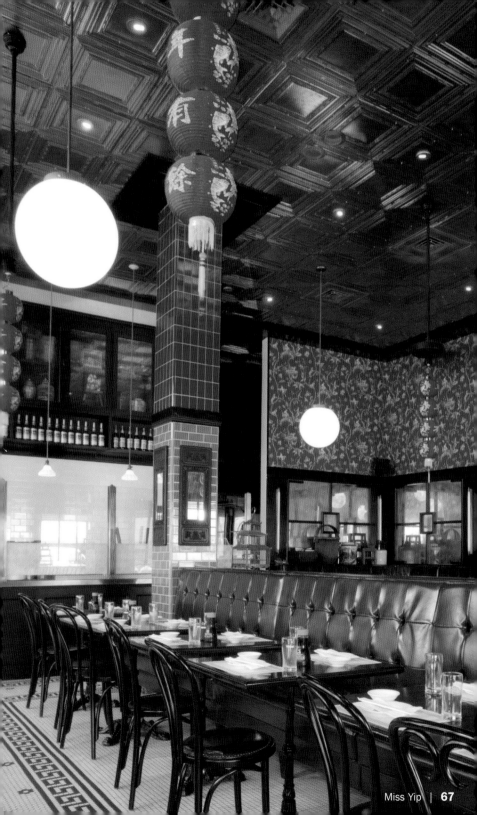

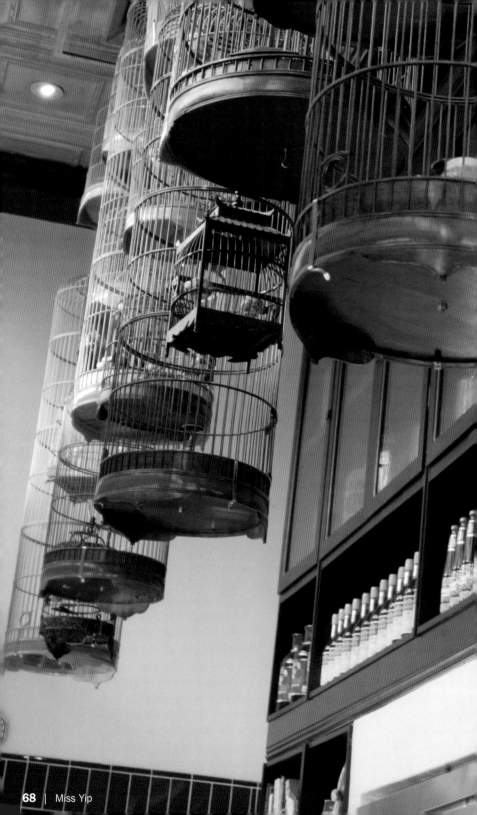

Siu Mai & Har Gau

Dim Sums

Siu Mai & Har Gau Dim Sums

Dim sums Siu Mai & Har Gau

Siu Mai & Har Gau dim sums

Dim sum di Siu Mai e Har Gau

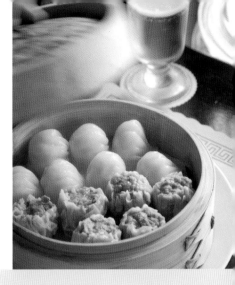

15 oz flour
240 ml water
Combine to a soft dough, chill for 30 minutes.

"Siu Mai" Ingredients:
4 oz pork
4 shiitake mushrooms, chopped
4 water chestnuts, chopped
Sugar, salt, pepper
1 tsp sesame oil
1 tsp rice vinegar
Mince the meat in a food processor, combine with the remaining ingredients and season with sugar, salt and pepper. Take one half of the dough and shape into circles, 2 inches in diameter. Place 1 tsp of the filling in the center, fold and press the edges firmly together.

"Har Gau" Ingredients:
4 oz shrimp meat, chopped
4 water chestnuts, chopped
2 tsp fresh coriander
Sugar, salt, pepper
Red curry paste for decoration
Combine all the ingredients in a bowl, season and set aside. Take the second half of the dough, color with green food coloring and shape into circles, 2 inches in diameter. Place 1 tsp of the filling in the center, fold and press the edges firmly together.

Steam both Dim Sum varieties in a wok for approx. 10 minutes. Turn over the Har Gau-Dim Sums, garnish with red curry paste and serve in a bamboo bowl, next to the Siu Mai-Dim Sums.

420 g Mehl
240 ml Wasser
Zu einem weichen Teig verarbeiten und 30 Minuten kalt stellen.

Siu-Mai-Zutaten:
120 g Schweinefleisch
4 Shiitakepilze, gehackt
4 Wasserkastanien, gehackt
Zucker, Salz, Pfeffer
1 TL Sesamöl
1 TL Reisessig
Fleisch durch den Wolf drehen, mit den restlichen Zutaten mischen, mit Zucker, Salz und Pfeffer würzen. Aus der einen Hälfte des Teiges 5 cm grosse Kreise formen. 1 TL der Füllung daraufgeben, zusammenklappen und die Ränder fest andrücken.

Har-Gau-Zutaten:
120 g Shrimpsfleisch, gehackt
4 Wasserkastanien, gehackt
2 TL frischer Koriander
Zucker, Salz, Pfeffer
Rote Currypaste als Garnierung
Alle Zutaten in eine Schüssel geben, würzen und beiseite stellen. Die zweite Hälfte des Teiges nehmen, mit grüner Lebensmittelfarbe einfärben und 5 cm große Kreise formen. 1 TL der Füllung daraufgeben, zusammenklappen und die Ränder fest andrücken.

Beide Dim-Sum-Variationen im Wok für ca. 10 Minuten dämpfen. Die Har-Gau-Dim-Sums umdrehen, mit roter Currypaste garnieren und in einer Bambusschüssel neben den Siu-Mai-Dim-Sums servieren.

420 g de farine
240 ml d'eau
Mélanger de façon à obtenir une pâte molle et mettre au frais pendant 30 minutes.

Ingrédients pour le « Siu Mai » :
120 g de viande de porc
4 champignons Shiitake, hachés
4 châtaignes d'eau, hachées
Sucre, sel, poivre
1 c. à café d'huile de sésame
1 c. à café de vinaigre de riz
Hacher la viande, mélanger aux ingrédients restants, assaisonner avec le sucre, le sel et le poivre. Former des cercles de 5 cm de diamètre avec la moitié de la pâte. Ajouter 1 cuillère à café de la garniture, refermer et bien appuyer sur les bords.

Ingrédients pour le « Har Gau » :
120 g de chair de crevettes, hachée
4 châtaignes d'eau, hachées
2 c. à café de coriandre fraîche
Sucre, sel, poivre
Pâte de curry rouge pour garnir
Mettre tous les ingrédients dans un récipient, saler et poivrer et mettre de côté. Prendre la seconde moitié de la pâte, la colorer avec du colorant alimentaire vert et former des cercles de 5 cm de diamètre. Ajouter 1 cuillère à café de la garniture, refermer et bien appuyer sur les bords.

Faire étuver dans le wok les deux sortes de dim sum pendant environ 10 minutes. Retourner les dim sum Har Gau, garnir de pâte de curry rouge et les servir dans un plat en bambou à côté des dim sum Siu Mai.

420 g de harina
240 ml de agua
Amase hasta conseguir una masa suave y resérvela en un lugar frío durante 30 minutos.

Ingredientes para el Siu Mai:
120 g de carne de cerdo
4 setas shiitake, picadas
4 castañas de agua, picadas
Azúcar, sal, pimienta
1 cucharadita de aceite de sésamo
1 cucharadita vinagre de arroz
Pase la carne por la picadora de carne, mézclela con los demás ingredientes y sazone con la sal, el azúcar y la pimienta. Divida la masa en dos mitades y de una de ellas haga círculos de 5 cm de diámetro. Ponga encima 1 cucharadita del relleno, doble los bordes y presiónelos.

Ingredientes para el Har Gau:
120 g de carne de langostino, picada
4 castañas de agua, picadas
2 cucharaditas de cilantro fresco
Azúcar, sal, pimienta
Pasta de curry roja para decorar
Ponga todos los ingredientes en un cuenco, sazónelos y reserve. Coloree la otra mitad de la masa con colorante verde apto para alimentos y córtela en círculos de 5 cm de diámetro. Ponga encima 1 cucharadita del relleno, doble los bordes y presiónelos.

Cueza al vapor las dos variaciones de dim sum en un wok durante aprox. 10 minutos. Dé la vuelta a los har gau dim sums, decore con la pasta de curry y sírvalos junto con los siu mai dim sums en un cuenco de bambú.

420 g di farina
240 ml di acqua
Lavorate gli ingredienti fino a formare un impasto morbido, che metterete poi a raffreddare per 30 minuti.

Ingredienti per „Siu Mai":
120 g di carne di maiale
4 funghi shiitake tritati
4 castagne d'acqua cinesi tritate
Zucchero, sale, pepe
1 cucchiaino di olio di sesamo
1 cucchiaino di aceto di riso
Macinate la carne con il tritacarne, mescolatela agli altri ingredienti, zuccherate, salate e pepate. Con una metà dell'impasto formate cerchi di 5 cm. Mettetevi sopra 1 cucchiaino di ripieno, chiudete piegando e premete energicamente sui bordi.

Ingredienti per „Har Gau":
120 g di polpa di gamberetti tritata
4 castagne d'acqua tritate
2 cucchiaini di coriandolo fresco
Zucchero, sale, pepe
Pasta di curry rossa per guarnire
Mettete tutti gli ingredienti in una ciotola, conditeli e metteteli da parte. Prendete la seconda metà dell'impasto, coloratela con colorante per alimenti verde e formate dei cerchi di 5 cm. Mettetevi sopra 1 cucchiaino di ripieno, chiudete piegando e premete energicamente sui bordi.

Fate cuocere a vapore entrambe le variazioni di dim sum in un wok per ca. 10 minuti. Girate i dim sum Har Gau, guarniteli con pasta di curry rossa e serviteli in una ciotola di bambù vicino ai dim sum Siu Mai.

Nemo

Design: Carl Meyers | Chef: Mike Sabin | Owner: Myles Chefetz

100 Collins Avenue | Miami, FL 33139 | South Beach
Phone: +1 305 532 4550
www.nemorestaurant.com
Opening hours: Lunch Mon–Sat noon to 3 pm, dinner Mon–Sun 6 pm to midnight,
brunch Sun 11 am to 3 pm
Average price: $ 65
Cuisine: New American
Special features: Sunday brunch, raw bar, outdoor dining, food bar, open kitchen

Nikki Beach Club

Design: Adam T. Tihany | Chef: Jason McClain
Owners: Jack & Lucia Penrod

1 Ocean Drive | Miami, FL 33139 | South Beach
Phone: +1 305 538 1111
www.nikkibeach.com
Opening hours: Every day 11 am to 2 am, kitchen Mon–Sat 11 am to 5 pm,
Sun 11 am to 10 pm
Average price: $ 13
Cuisine: Sushi
Special features: Attended by celebrities and a-list clients during the day

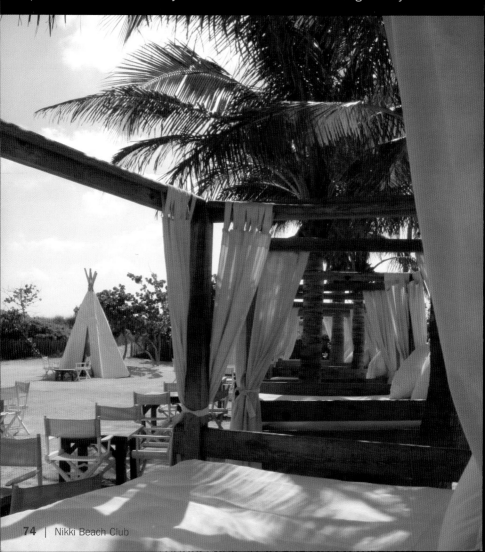

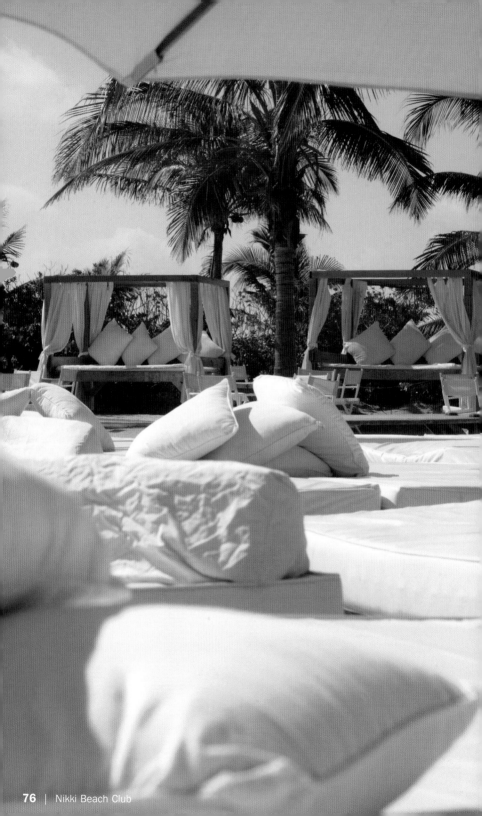

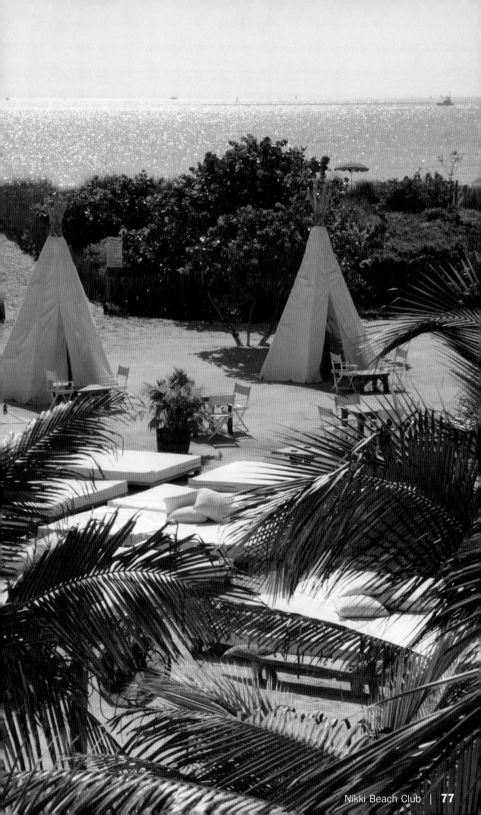

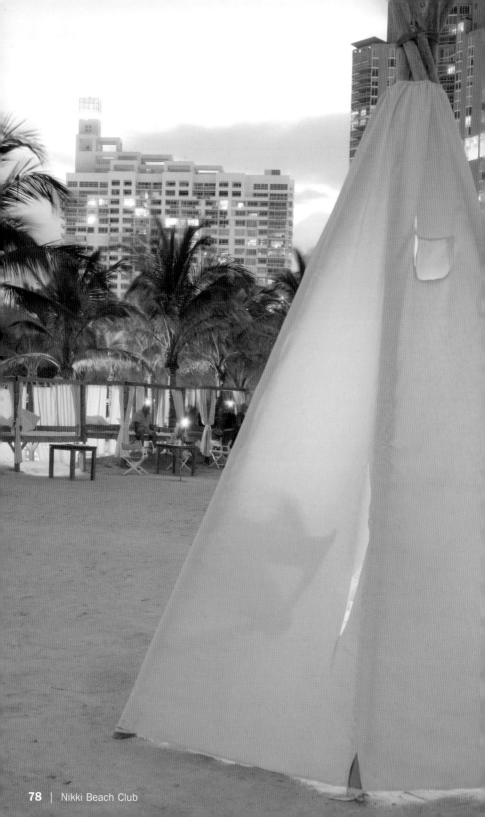

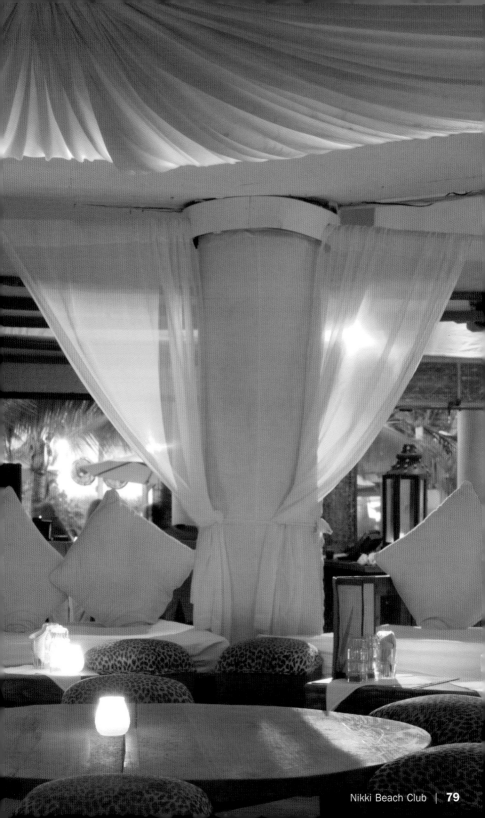

Pacific Time

Design, Chef & Owner: Jonathan Eismann

915 Lincoln Road | Miami, FL 33139 | South Beach
Phone: +1 305 534 5979
www.pacifictime.biz
Opening hours: Lunch Mon–Fri 11:30 am to 2:30 pm seasonal, dinner every day
6 pm to midnight
Average price: $ 51
Cuisine: Pan-Asian, seafood
Special features: Sidewalk cafe

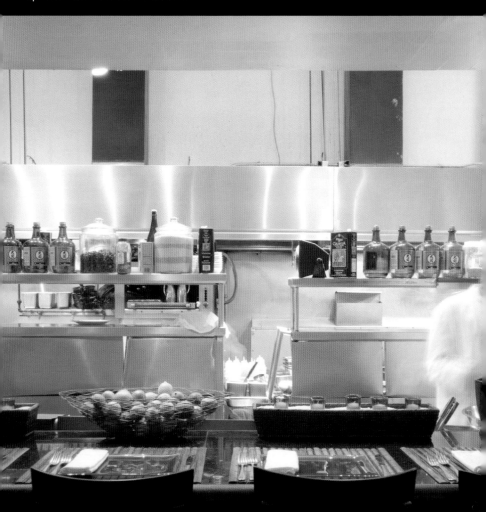

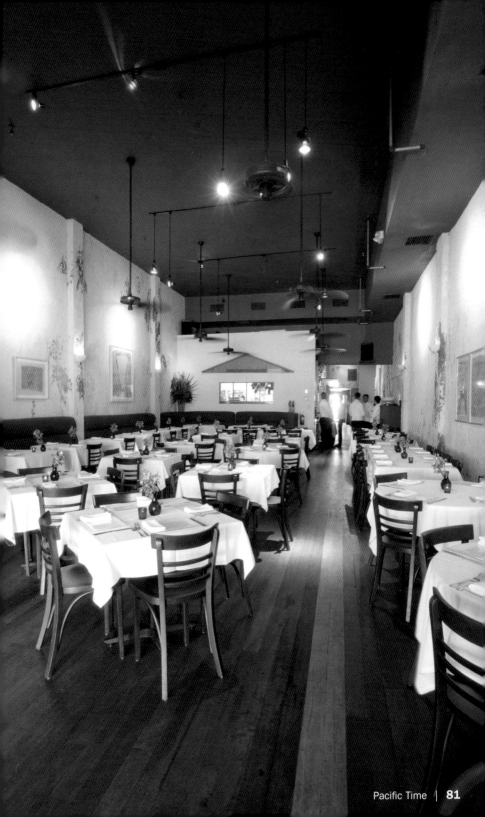

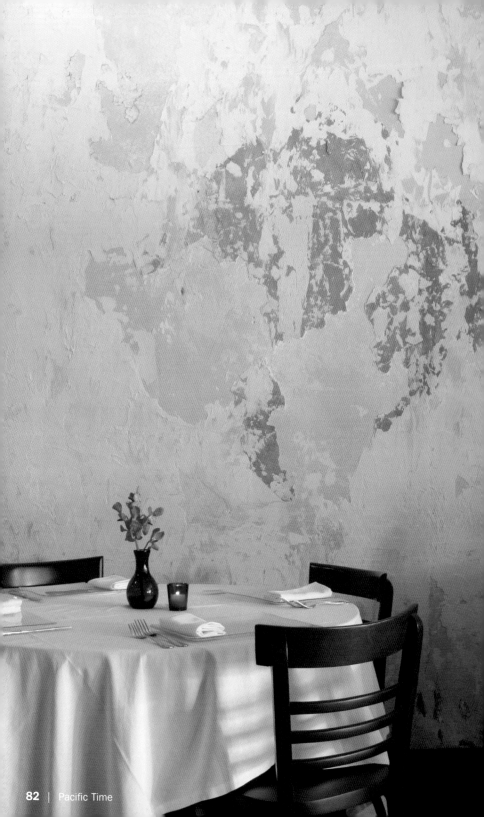

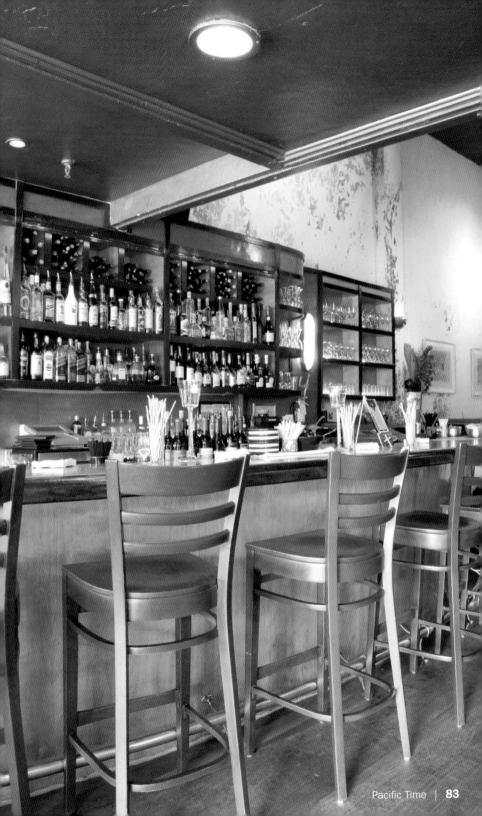

Wild Salmon Tartar

Wildlachstartar

Tartare de saumon sauvage

Tartar de salmón salvaje

Tartara di salmone selvatico

Dry cure:
16 oz sugar
2 oz maple sugar
12 1/2 oz salt
4 tbsp lemon rind, grated
4 oz lemon grass, chopped
4 oz dill, chopped
17 oz fresh wild salmon filet
Combine all the ingredients in a bowl. Spoon half of the mixture into a deep dish, place the salmon on top and cover with the reserved cure mixture. Refrigerate for 10–12 hours. Remove from the dry cure, wash and dry off very well. Cut into small pieces.

1 tsp chili oil
2 tbsp red onion, chopped
2 tbsp chives, chopped
2 tbsp shiso leaves, chopped
2 tbsp chervil leaves, chopped

2 tbsp rice vinegar
2 tbsp lemon juice
Salt, pepper
Mix the salmon pieces with the seasoning. Refrigerate.

For Japanese Guacamole:
4 oz avocado, diced
Juice of 1 lemon
4 oz cucumber, diced
2 tbsp tobiko (flying fish roe)
2 tsp wasabi
Salt, pepper
Cress for decoration
Mix together all the ingredients. Chill. Place a ring-mould on the plate, spoon in the salmon tartar and cover with guacamole. Press lightly to secure the shape and remove the mould. Garnish with cress.

Trockenbeize:
450 g Zucker
60 g Ahornzucker
360 g Salz
4 EL Zitronenschale, geraspelt
120 g Zitronengras, gehackt
120 g Dill, gehackt
480 g frisches Wildlachsfilet
Alle Zutaten in einer Schüssel mischen. Die Hälfte der Mischung in eine tiefe Form geben, den Lachs daraufgeben und mit der restlichen Mischung bedecken. Für 10–12 Stunden kalt stellen. Aus der Trockenbeize nehmen, abwaschen und gut abtrocknen. In kleine Stücke schneiden.

1 TL Chiliöl
2 EL rote Zwiebel, gehackt
2 EL Schnittlauch, gehackt
2 EL Shisoblätter, gehackt

2 EL Kerbel, gehackt
2 EL Reisessig
2 EL Zitronensaft
Salz, Pfeffer
Die Lachsstücke mit den Gewürzen mischen. Kalt stellen.

Japanische Guacamole:
120 g Avocado, gewürfelt
Saft einer Zitrone
120 g Gurke, gewürfelt
2 EL Tobiko (Rogen von Fliegenden Fischen)
2 TL Wasabi
Salz, Pfeffer
Kressemix zum Garnieren
Alle Zutaten mischen. Kalt stellen. Eine Ringform auf den Teller legen, den Tartar hineingeben und mit Guacamole bedecken. Leicht andrücken, um die Form zu halten, und den Ring entfernen. Mit Kressemix garnieren.

Marinade sèche :
450 g de sucre
60 g de sucre d'érable
360 g de sel
4 c. à soupe de zeste de citron, râpé
120 g de citronnelle, hachée
120 g d'aneth, haché
480 g de filet de saumon sauvage frais
Mélanger tous les ingrédients dans un récipient.
Verser la moitié du mélange dans un moule creux, ajouter le saumon et recouvrir du mélange restant. Mettre au frais pendant 10–12 heures. Retirer de la marinade sèche, rincer et bien sécher. Couper en petits morceaux.

1 c. à café d'huile de chili
2 c. à soupe d'oignon rouge, haché
2 c. à soupe de ciboulette, hachée
2 c. à soupe de feuilles de shiso, hachées
2 c. à soupe de cerfeuil, haché

2 c. à soupe de vinaigre de riz
2 c. à soupe de jus de citron
Sel, poivre
Mélanger les morceaux de saumon aux épices.
Mettre au frais.

Guacamole japonais :
120 g d'avocat, coupé en dés
Le jus d'un citron
120 g de concombres, coupés en dés
2 c. à soupe de tobiko (œufs de poissons volants)
2 c. à café de wasabi
Sel, poivre
Mélange de cresson pour la garniture
Mélanger tous les ingrédients. Mettre au frais.
Placer un cercle autour de l'assiette, y ajouter le tartare et recouvrir de guacamole. Enfoncer légèrement pour conserver la forme et retirer le cercle. Garnir avec le mélange de cresson.

Adobo:
450 g de azúcar
60 g de azúcar de arce
360 g de sal
4 cucharadas de piel de limón, rallada
120 g de limoncillo, picado
120 g de eneldo, picado
480 g de salmón salvaje fresco
Mezcle los ingredientes en un cuenco. Ponga la mitad de la mezcla en un molde hondo, coloque encima el salmón y cúbralo con el resto de la mezcla. Póngalo en el frigorífico entre 10–12 horas. Saque el salmón del adobo, lávelo y séquelo bien. Córtelo en pequeñas porciones.

1 cucharadita de aceite de guindilla
2 cucharadas de cebolla roja, picada
2 cucharadas de cebollino, picado
2 cucharadas de hojas shiso, picadas
2 cucharadas de perifollo, picado

2 cucharadas de vinagre de arroz
2 cucharadas de zumo de limón
Sal, pimienta
Sazone los trozos de salmón con las especias.
Póngalos después en el frigorífico.

Guacamole japonés:
120 g de aguacate, en dados
Zumo de un limón
120 g de pepino, en dados
2 cucharadas de tobiko (huevas de pez volador)
2 cucharadita de wasabi
Sal, pimienta
Mezcla de berros para adornar
Mezcle todos los ingredientes. Ponga la mezcla en el frigorífico. Coloque un anillo en los platos, ponga dentro el tartar y cúbralo con el guacamole. Presione ligeramente para que se mantenga la forma y retire el anillo. Adorne con los berros.

Marinata "secca":
450 g di zucchero
60 g di zucchero di acero
360 g di sale
4 cucchiai di scorza di limone grattugiata
120 g di cimbopogone tritato
120 g di aneto tritato
480 g di filetto di salmone selvatico fresco
Mescolate tutti gli ingredienti in una ciotola. Mettete metà della marinata in uno stampo profondo, sistematevi sopra il salmone e ricoprite con il resto della marinata. Mettete a raffreddare per 10–12 ore. Togliete dalla marinata, lavate e asciugate bene. Tagliate a pezzi piccoli.

1 cucchiaino di olio al peperoncino
2 cucchiai di cipolla rossa tritata
2 cucchiai di erba cipollina tritata
2 cucchiai di foglie di shiso tritate
2 cucchiai di cerfoglio tritato

2 cucchiai di aceto di riso
2 cucchiai di succo di limone
Sale, pepe
Mescolate i pezzi di salmone con le spezie.
Mettete a raffreddare.

Guacamole giapponese:
120 g di avocado tagliato a dadini
Succo di un limone
120 g di cetriolo tagliato a dadini
2 cucchiai di tobiko (uova di pesce volante)
2 cucchiaini di wasabi
Sale, pepe
Mix di crescione per guarnire
Mescolate tutti gli ingredienti e mettete a raffreddare. Appoggiate sul piatto un anello senza fondo, mettetevi dentro la tartara e ricoprite con guacamole. Premete leggermente per dare forma al tutto e togliete l'anello. Guarnite con il mix di crescione.

Pearl

Design: Stephane Dupoux, Lubna Zawawi
Owners: Jack & Lucia Penrod

1 Ocean Drive | Miami, FL 33139 | South Beach
Phone: +1 305 538 1111
www.pearlsouthbeach.com
Opening hours: Wed–Thu 7 pm to 11 pm, Fri–Sat 7 pm to 1 am, lounge 7 pm
to 5 am
Average price: $ 30
Cuisine: American, fusion, eclectic, seafood
Special features: Attended by celebrities and a-list clients during night

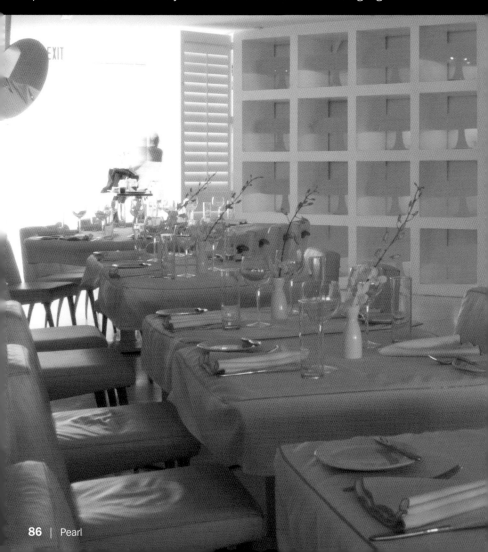

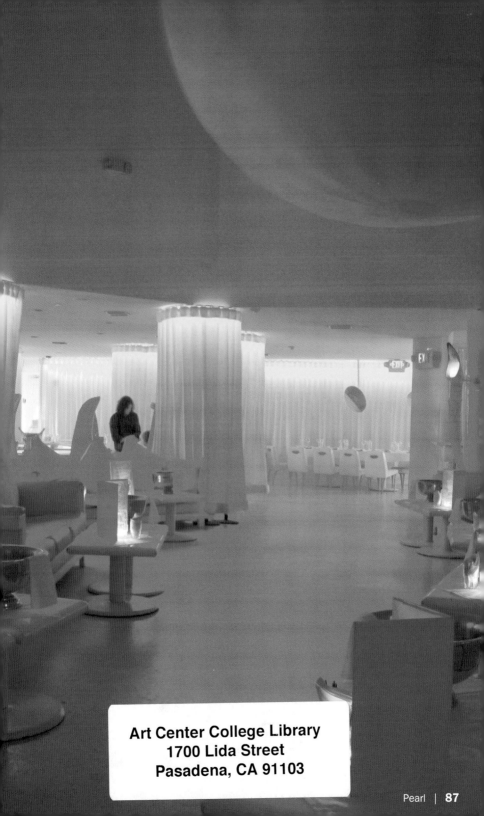

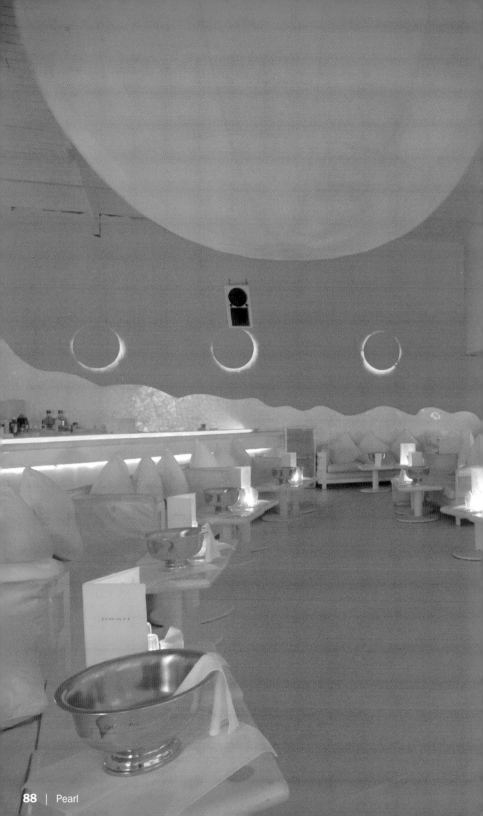

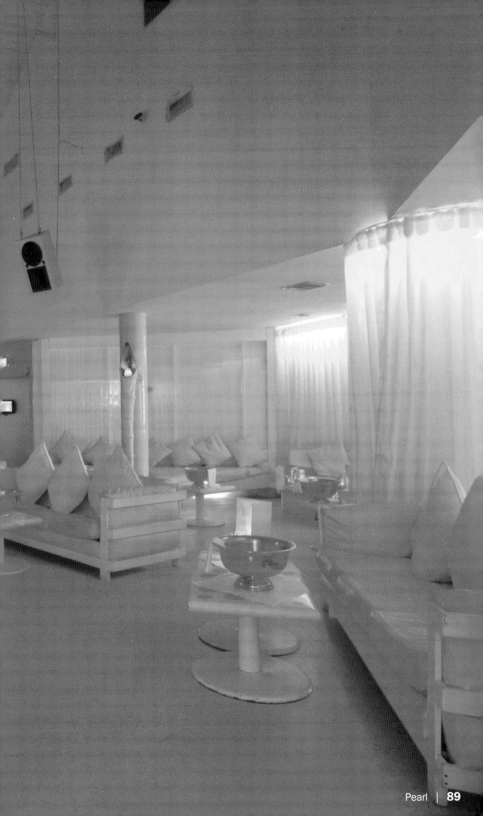

Beef Filet

with Mashed Lobster Potatoes

Rinderfilet mit Hummer-Kartoffelpüree

Filets de bœuf à la purée de pommes de terre et de homard

Filete de ternera con puré de langosta y patata

Filetto di manzo con purè di patate all'astice

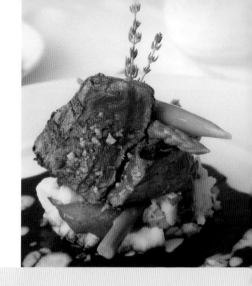

4 beef tenderloin, 8 oz each
4 large potatoes
60 ml milk
8 oz butter
12 1/2 oz lobstermeat (chunks)
2 tbsp spring onions, chopped
16 asparagus spears
2 tbsp butter for frying
1 tbsp garlic, chopped
1 tbsp shallot, chopped
240 ml red wine
240 ml port wine
1 tbsp sugar
5 tbsp butter
Salt, pepper

Boil the potatoes until soft, peel and mash with the milk, butter, lobster meat and spring onions. Season to taste. Melt the butter in a pan and sauté the asparagus spears, garlic and shallots until they are glazed. Season with salt and pepper. Season both sides of the beef with salt and pepper. Brown in a pan on both sides, and place in a 480 °F oven for 5 minutes. Combine red wine, port wine and sugar in a pot and reduce to a syrup. Once the sauce begins to thicken add a little cold butter. Before slicing, allow the meat to rest for a minute. Slice the meat and sprinkle with a little salt. Spoon the mashed potatoes on a plate, place beef and asparagus on top and drizzle with sauce.

4 Rinderfiletstücke, je 240 g
4 große Kartoffeln
60 ml Milch
240 g Butter
360 g Hummerfleisch (Stücke)
2 EL Frühlingszwiebeln, gehackt
16 Spargelspitzen
2 EL Butter zum Anbraten
1 EL Knoblauch, gehackt
1 EL Schalotten, gehackt
240 ml Rotwein
240 ml Portwein
1 EL Zucker
5 EL Butter
Salz, Pfeffer

Kartoffeln weichkochen, schälen und mit der Milch, der Butter, dem Hummerfleisch und den Frühlingszwiebeln pürieren. Abschmecken. Die Butter in einer Pfanne schmelzen und Spargelspitzen, Knoblauch und Schalotten sautieren, bis sie glasiert sind. Mit Salz und Pfeffer abschmecken. Beide Seiten des Rinderfilets mit Salz und Pfeffer würzen. In einer Pfanne auf beiden Seiten anbraten und für 5 Minuten in einen 250 °C heißen Ofen geben. Rotwein, Portwein und Zucker in einen Topf geben und zu einem Sirup reduzieren. Wenn die Sauce anfängt anzudicken, etwas kalte Butter zugeben. Vor dem Tranchieren das Fleisch 1 Minute ruhen lassen. In Scheiben schneiden und mit etwas Salz bestreuen. Kartoffelpüree auf den Teller geben, Rinderfilet und Spargel darauflegen und mit der Sauce beträufeln.

4 filets de bœuf, de 240 g chacun
4 grosses pommes de terre
60 ml de lait
240 g de beurre
360 g de chair de homard (en morceaux)
2 c. à soupe de petits oignons grelots, hachés
16 pointes d'asperge
2 c. à soupe de beurre à frire
1 c. à soupe d'ail, haché
1 c. à soupe d'échalotes, hachées
240 ml de vin rouge
240 ml de Porto
1 c. à soupe de sucre
5 c. à soupe beurre
Sel, poivre

Cuire les pommes de terre jusqu'à ce qu'elles soient tendres, les éplucher et les réduire en purée avec le lait, le beurre, la chair de homard et les petits oignons grelots. Saler et poivrer. Faire fondre le beurre dans une poêle et faire revenir les pointes d'asperge, l'ail et les échalotes jusqu'à ce qu'ils soient glacés. Assaisonner. Saler et poivrer les deux côtés des filets de boeuf. Dans une poêle, les faire rissoler des deux côtés et mettre pendant 5 minutes au four à 250 °C. Mettre dans une casserole le vin rouge, le Porto et le sucre et réduire en sirop. Lorsque la sauce commence à épaissir, ajouter un peu de beurre froid. Laisser reposer la viande pendant une minute avant de la couper. La couper en tranches et saupoudrer d'un peu de sel. Disposer la purée de pommes de terre sur les assiettes, ajouter par-dessus le filet de bœuf et arroser de sauce.

4 filetes de ternera, cada uno de 240 g
4 patatas grandes
60 ml de leche
240 g de mantequilla
360 g de carne de langosta (troceada)
2 cucharadas de cebolletas, picadas
16 puntas de espárragos
2 cucharadas de mantequilla para freír
1 cucharada de ajo, picado
1 cucharada de chalote, picado
240 ml de vino tinto
240 ml de oporto
1 cucharada de azúcar
5 cucharadas de mantequilla
Sal, pimienta

Cueza las patatas hasta que estén blandas, pélelas y hágalas puré junto con la leche, la mantequilla, la carne de langosta y la cebolleta. Salpimiente al gusto. Derrita la mantequilla en una sartén y saltee las puntas de los espárragos, el ajo y el chalote hasta que estén glaseados. Salpimiente la mezcla. Salpimiente los filetes por ambos lados. Fríalos por los dos lados en una sartén y áselos después en un horno precalentado a 250 °C durante 5 minutos. Ponga el vino tinto, el oporto y el azúcar en una cazuela y reduzca la mezcla hasta obtener un sirope. Cuando la salsa empiece a espesarse añada un poco de mantequilla fría. Antes de trinchar la carne deje que repose durante un minuto. Córtela en lonchas y esparza con la sal. Reparta el puré de patata en los platos, coloque encima el filete y los espárragos y vierta por encima la salsa.

4 pezzi di filetto di manzo da 240 g l'uno
4 patate grosse
60 ml di latte
240 g di burro
360 g di polpa di astice (a pezzi)
2 cucchiai di cipollotto tritato
16 punte di asparagi
2 cucchiai di burro per rosolare
1 cucchiaio di aglio tritato
1 cucchiaio di scalogni tritati
240 ml di vino rosso
240 ml di vino porto
1 cucchiaio di zucchero
5 cucchiai di burro
Sale, pepe

Lessate bene le patate, riducetele in purea con latte, burro, polpa di astice e cipollotti. Correggete di sapore. In una padella fate sciogliere il burro e fatevi saltare le punte di asparagi, l'aglio e gli scalogni finché saranno glassati. Correggete di sale e pepe. Salate e pepate i filetti di manzo da entrambi i lati. Fateli rosolare in una padella da ogni lato e passateli in forno caldo a 250 °C per 5 minuti. In una pentola mettete il vino rosso, il vino porto e lo zucchero e fate consumare il liquido fino ad ottenere uno sciroppo. Quando questa salsa inizierà ad ispessirsi, aggiungete un po' di burro freddo. Lasciate riposare la carne prima di tagliarla a fette. Tagliate quindi a fette e cospargete con un po' di sale. Mettete del purè di patate sul piatto, sistematevi sopra il filetto di manzo e gli asparagi e versatevi alcune gocce di salsa.

Prime 112

Design: Alison Antrobus, Allan Shulman | Chef: Mike Sabin
Owner: Myles Chefetz

112 Ocean Drive | Miami, FL 33139 | South Beach
Phone: +1 305 532 8112
www.prime112.com
Opening hours: Lunch Mon–Fri noon to 3 pm, dinner nightly Sun–Thu 6:30 pm
to midnight, Fri–Sat 6:30 pm to 1 am
Average price: from $ 50
Cuisine: Modern steakhouse
Special features: Prime dry aged beef, fresh local seafood, extensive wine list

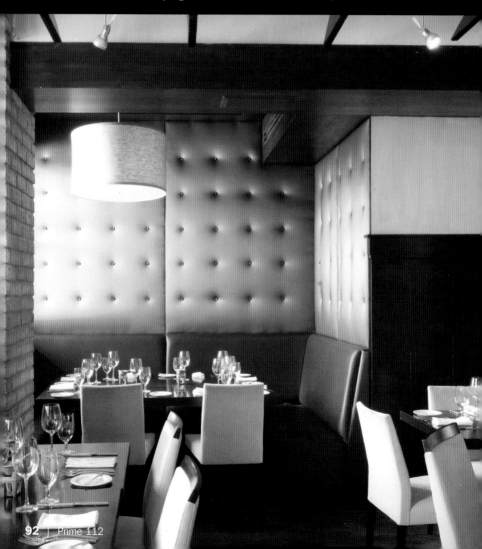

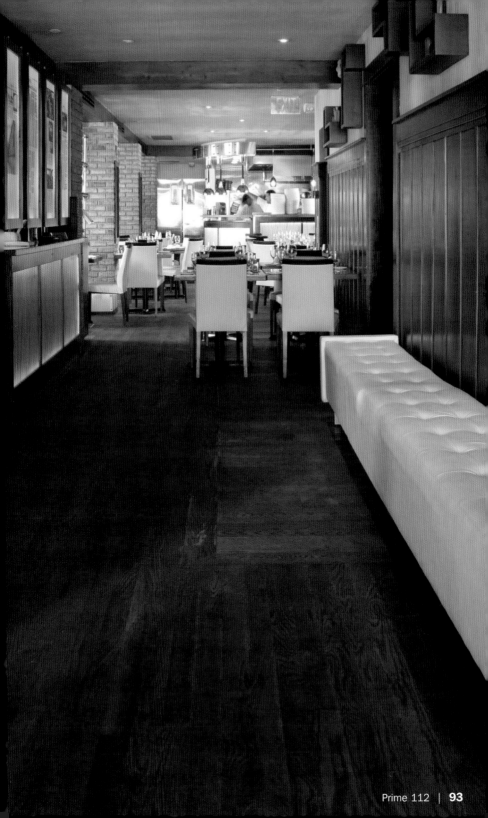

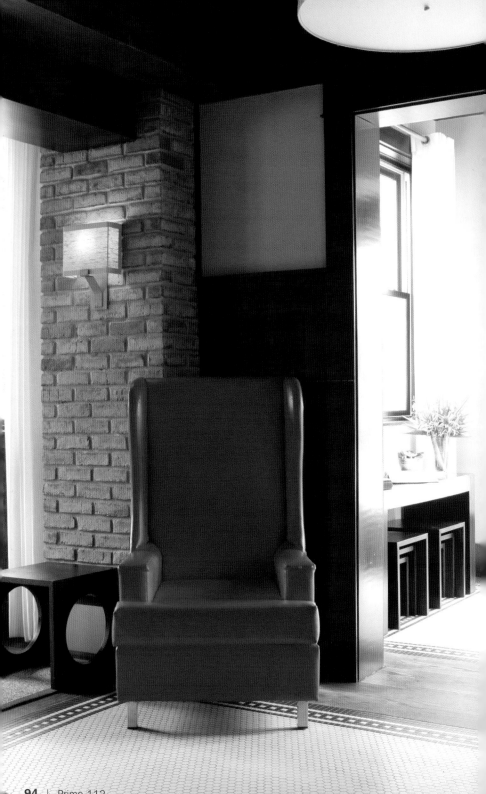

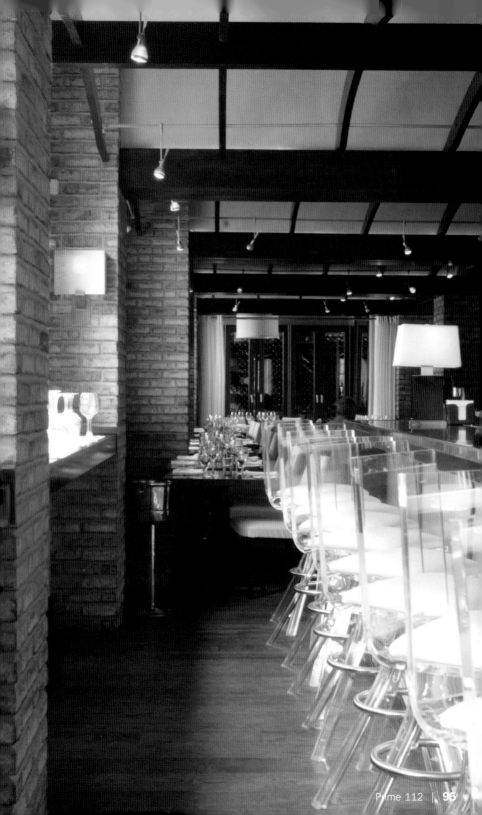

Stuffed Lobster

Gefüllter Hummer

Homard farci

Langosta rellena

Astice farcito

Stuffing:
2 carrots, diced
4 celery sticks, diced
1 onion, diced
6 tbsp butter
1 bunch of parsley, chopped
1 bunch thyme, chopped
1 loaf of brioche (dry and cut the same size as vegetables)
8 oz prawn meat
3 oz scallops (pre-cooked)
10 1/2 oz butter, melted
Salt, pepper

Sauté the vegetables in hot butter until tender, then mix with parsley, thyme and brioche. Season with salt and pepper. Add the prawn meat and scallops, stir in the butter and mix until moist.

Lobster:
Boil 2 lobsters in salted water and cook for about 4 minutes. Remove while half cooked and allow to rest until they are cool enough to handle. Crack the claws and joints and split the tail except the part that fans out. Fill with the stuffing and place on a baking sheet. Bake in oven for 4–6 minutes at 400 °F. Garnish the plates with the lemon and chopped chives.

Füllung:
2 Möhren, gewürfelt
4 Stangen Sellerie, gewürfelt
1 Zwiebel, gewürfelt
6 EL Butter
1 Bund Petersilie, gehackt
1 Bund Thymian, gehackt
1 Laib Brioche (trocken und in der gleichen Größe wie das Gemüse geschnitten)
240 g Garnelenfleisch
90 g Kammmuscheln (gekocht)
300 g Butter, geschmolzen
Salz, Pfeffer

Das Gemüse in der heißen Butter sautieren bis es weich ist, dann mit Petersilie, Thymian und Brioche mischen. Mit Salz und Pfeffer würzen. Garnelenfleisch und Kammmuscheln zugeben, die Butter unterrühren und so lange mischen bis alles durchfeuchtet ist.

Hummer:
2 Hummer in gesalzenem Wasser für ca. 4 Minuten kochen. Noch halbroh herausnehmen und abkühlen lassen, bis man sie anfassen kann. Scheren und Gelenke knacken und den Schwanz bis auf den Schwanzfächer zerteilen. Mit der Füllung füllen und auf ein Backblech geben. Bei 200 °C ca. 4–6 Minuten backen. Die Teller mit Zitrone und gehacktem Schnittlauch garnieren.

Farce :
2 carottes, coupées en dés
4 branches de céleri, coupées en dés
1 oignon, coupé en dés
6 c. à soupe beurre
1 bouquet de persil, haché
1 bouquet de thym, haché
1 boule de brioche (de la veille et coupée de la même taille que les légumes)
240 g de chair de crevettes
90 g de pétoncles (cuites)
300 g de beurre fondu
Sel, poivre

Faire revenir les légumes dans le beurre chaud jusqu'à ce qu'il soient tendres, puis mélanger avec le persil, le thym et la brioche. Saler et poivrer. Ajouter la chair des crevettes et les pétoncles, ajouter le beurre et mélanger jusqu'à ce que tout soit bien imprégné.

Homard :
Cuire 2 homards dans l'eau salée pendant environ 4 minutes. Les retirer à mi-cuisson et les laisser refroidir pour pouvoir les découper ensuite. Casser les pinces et les articulations et diviser la queue jusqu'à l'éventail. La remplir avec la farce et la placer sur la plaque du four. Cuire à 200 °C pendant environ 4–6 minutes. Garnir les assiettes avec du citron et de la ciboulette hachée.

Relleno:
2 zanahorias, en dados
4 ramas de apio, en dados
1 cebolla, en dados
6 cucharadas de mantequilla
1 manojo de perejil, picado
1 manojo de tomillo, picado
1 pan brioche (seco y cortado en porciones del tamaño de la verdura)
240 g de carne de langostino
90 g de pechinas (hervidas)
300 g de mantequilla, derretida
Sal, pimienta

Saltee la verdura en la mantequilla caliente hasta que esté blanda, añada después el perejil, el tomillo y el pan y remueva. Salpimiente. Incorpore la carne de langostino y las pechinas, añada la mantequilla y remueva hasta que todos los ingredientes estén humedecidos.

Langosta:
Hierva 2 langostas en agua hirviendo con sal durante aprox. 4 minutos. Sáquelas del agua todavía medio crudas y déjelas enfriar hasta que pueda tocarlas sin quemarse. Rompa las pinzas y las articulaciones y trocee las colas excepto los apéndices. Rellene con la mezcla y póngalas en una bandeja del horno. Áselas a 200 °C entre 4–6 minutos. Adorne los platos con limón y cebollino picado.

Ripieno:
2 carote tagliate a dadini
4 gambi di sedano tagliati a dadini
1 cipolla tagliata a dadini
6 cucchiai di burro
1 mazzetto di prezzemolo tritato
1 mazzetto di timo tritato
1 forma di brioche salata (secca e tagliata come la verdura)
240 g di polpa di gamberi
90 g di canestrelli (lessati)
300 g di burro fuso
Sale, pepe

Fate saltare la verdura nel burro bollente finché sarà appassita, incorporate quindi il prezzemolo, il timo e la brioche. Salate e pepate. Aggiungete la polpa di gamberi e i canestrelli, incorporatevi il burro e mescolate finché il composto sarà ben inumidito.

Astici:
Fate bollire 2 astici in acqua salata per ca. 4 minuti. Toglieteli ancora semicrudi e fateli raffreddare finché riuscirete ad afferrarli. Rompete le chele e le giunture e aprite il corpo a metà per il lungo fermandovi alla coda a ventaglio. Farcite con il ripieno e mettete su una piastra da forno. Cuocete in forno caldo a 200 °C per ca. 4–6 minuti. Guarnite i piatti con limone ed erba cipollina tritata.

Raleigh Restaurant

Design: André Balazs Properties | Director of Cuisine: Eric Ripert
Executive Chef: Frederic Colin | Owner: André Balazs

1775 Collins Avenue | Miami, FL 33139 | South Beach
Phone: +1 305 534 6300
www.raleighhotel.com
Opening hours: Food is served 24 hours a day, breakfast from 7 am to noon,
lunch noon to 3 pm, dinner from 6 pm to midnight
Average price: $ 45
Cuisine: Latin with French influence
Special features: Indoor and outdoor dining; over looking, world famous pool

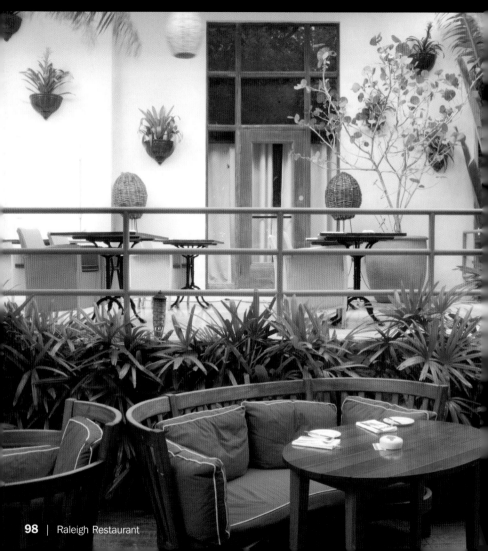

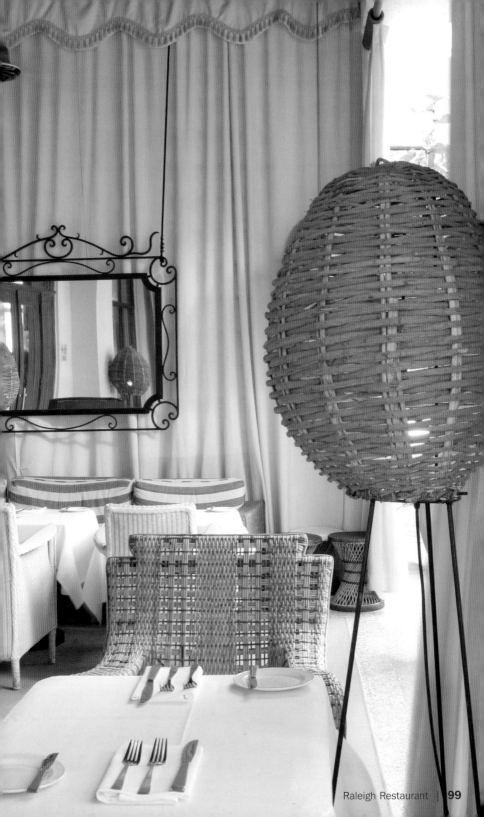

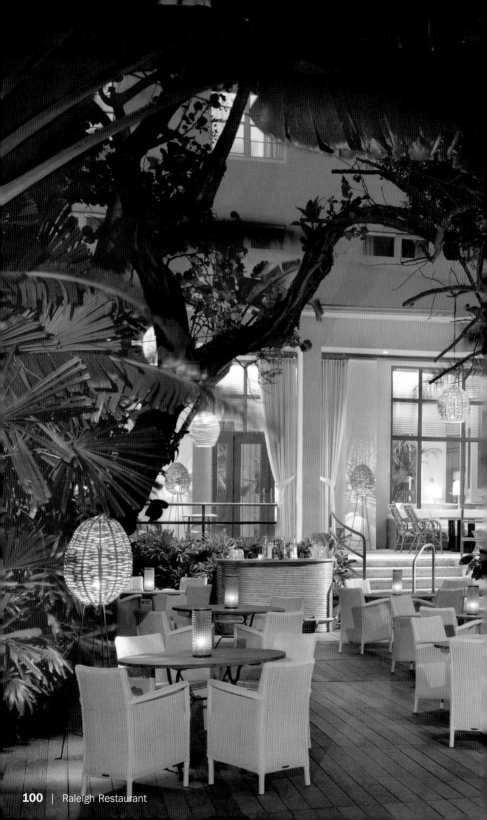

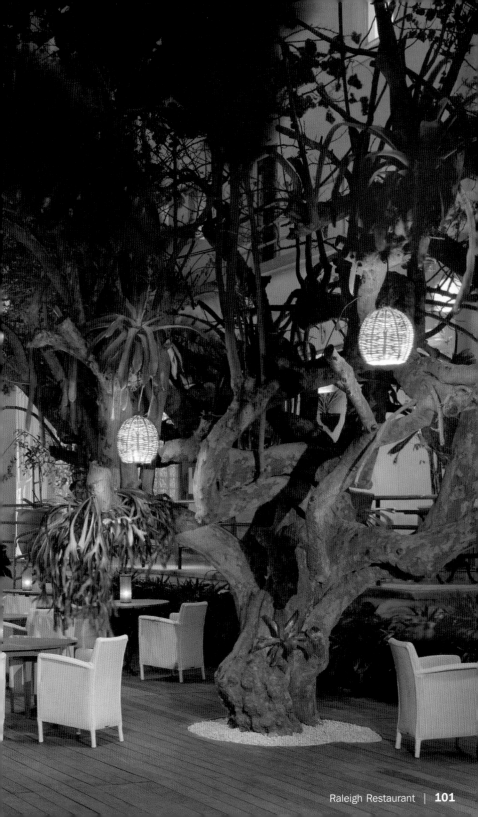

Tuna Tacos

Thunfisch-Tacos

Tacos au thon

Tacos de bonito

Taco al tonno

4 tuna steaks, 4 oz each
Salt, pepper
2 tbsp olive oil

4 tbsp mayonnaise
8 tbsp pomegranate juice, reduced to 1/3
Juice of 2 limes
Salt, pepper

4 tortillas
1 cucumber, sliced
1 carrot, shredded
1 avocado, sliced

Season the tuna and fry in a very hot pan for 1 minute on each side. Combine the mayonnaise, pomegranate juice and lime juice and season to taste. Cut each tuna steak into 5 pieces. Lightly toast the tortillas and spread the mayonnaise mixture on top. Top with cucumber, carrot, avocado and tuna. Roll up the tortilla tightly. Slice into 5 pieces and arrange on a serving dish.

4 Thunfischsteaks, je 120 g
Salz, Pfeffer
2 EL Olivenöl

4 EL Mayonnaise
8 EL Granatapfelsaft, auf 1/3 reduziert
Saft von 2 Limetten
Salz, Pfeffer

4 Tortillas
1 Gurke, in Scheiben
1 Möhre, geraspelt
1 Avocado, in Scheiben

Den Thunfisch würzen und in sehr heißem Öl von jeder Seite 1 Minute braten. Mayonnaise, Granatapfelsaft und Limettensaft mischen und abschmecken. Den Thunfisch jeweils in 5 Scheiben schneiden. Die Tortillas leicht toasten und mit der Mayonnaisemischung bestreichen. Mit Gurke, Möhre, Avocado und Thunfisch belegen. Die Tortilla fest einrollen. In 5 Stücke schneiden und auf einer Platte arrangieren.

4 steaks de thon, de 120 g chacun
Sel, poivre
2 c. à soupe d'huile d'olive

4 c. à soupe de mayonnaise
8 c. à soupe de jus de grenade, réduit au $1/3$
Le jus de 2 citrons verts
Sel, poivre

4 tortillas
1 concombre, en tranches
1 carotte, râpée
1 avocat, en tranches

Assaisonner le thon et le faire rissoler de chaque côté dans de l'huile très chaude pendant 1 minute. Mélanger la mayonnaise, le jus de grenade et le jus de citron vert et assaisonner. Couper chaque steak de thon en 5 tranches. Faire griller légèrement les tortillas et les badigeonner avec le mélange à base de mayonnaise. Garnir avec la carotte rapée et les tranches de concombre, d'avocat et de thon. Enrouler fermement la tortilla. Couper en 5 morceaux et disposer sur un plat.

4 filetes de bonito, cada uno de 120 g
Sal, pimienta
2 cucharadas de aceite de oliva

4 cucharadas de mayonesa
8 cucharadas de zumo de granada, reducido a $1/3$
Zumo de 2 limas
Sal, pimienta

4 tortillas
1 pepino, en rodajas
1 zanahoria, rallada
1 aguacate, en rodajas

Sazone el bonito y fríalo por cada lado durante 1 minuto en aceite muy caliente. Mezcle la mayonesa con el zumo de granada y de lima y salpimiente al gusto. Corte cada filete de bonito en 5 lonchas. Tueste ligeramente las tortillas y úntelas con la mezcla de la mayonesa. Cúbralas con el pepino, la zanahoria, el aguacate y el bonito. Enrolle las tortillas. Córtelas en 5 trozos y colóquelos en una bandeja.

4 tranci di tonno da 120 g l'uno
Sale, pepe
2 cucchiai di olio d'oliva

4 cucchiai di maionese
8 cucchiai di succo di melagrana ristretto ad $1/3$
Succo di 2 limette
Sale, pepe

4 tortilla
1 cetriolo a rondelle
1 carota grattugiata
1 avocado a fette

Condite il tonno e friggetelo nell'olio bollente per 1 minuto per lato. Mescolate insieme la maionese, il succo di melagrana e di limette e correggete di sapore. Tagliate ogni trancio di tonno in 5 fette. Tostate leggermente le tortilla e spalmatevi sopra il preparato alla maionese. Farcite con cetriolo, carota, avocado e tonno. Arrotolate le tortilla ben strette, tagliatele in 5 pezzi e disponetele su un piatto grande.

Rumi

Design: Naray Man NYC | Chef: J. P. Abbas
Owner: Carlos Garcia

330 Lincoln Road | Miami, FL 33139 | South Beach
Phone: +1 305 672 4353
www.rumimiami.com
Opening hours: Tue, Thu, Fri, Sat 7 pm to midnight, lounge open to 5 am
Average price: $ 60
Cuisine: Innovative tropical
Special features: Lounge with life Dj's, impressive musical line-up in an intimate, edgy setting

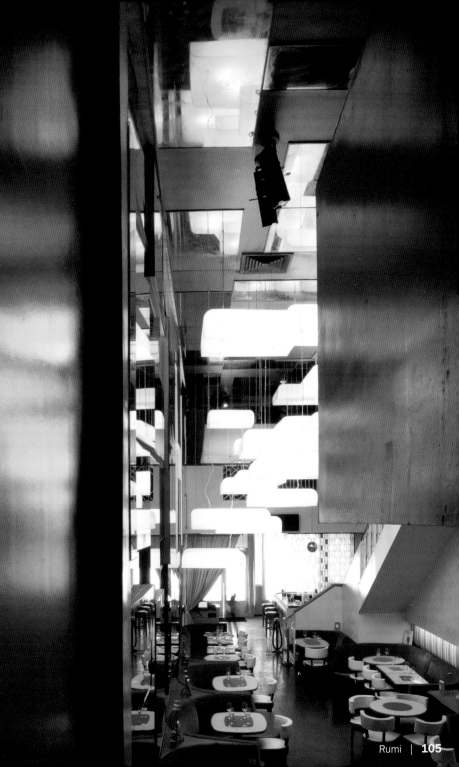

Tantra

Design: Stephane Dupoux | Chef: Sandee Bindsong
Owner: Timothy Hogle

1445 Pennsylvania Avenue | Miami, FL 33139 | South Beach
Phone: +1 305 672 4765
www.tantrarestaurant.com
Opening hours: Every day 7 pm to 1 am, Lounge until 5 am
Average price: $ 38
Cuisine: Aphrodisiac inspired International
Special features: Lounge, live music and entertainment, DJ's, dancers

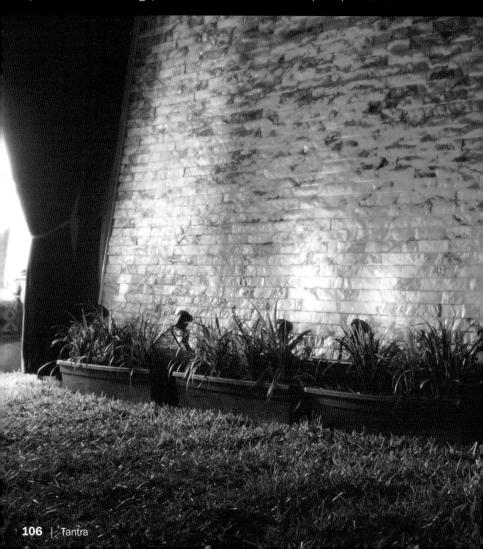

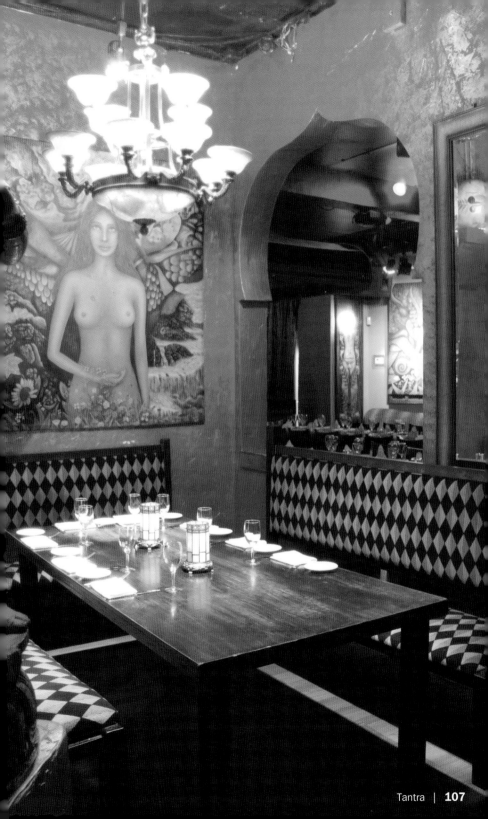

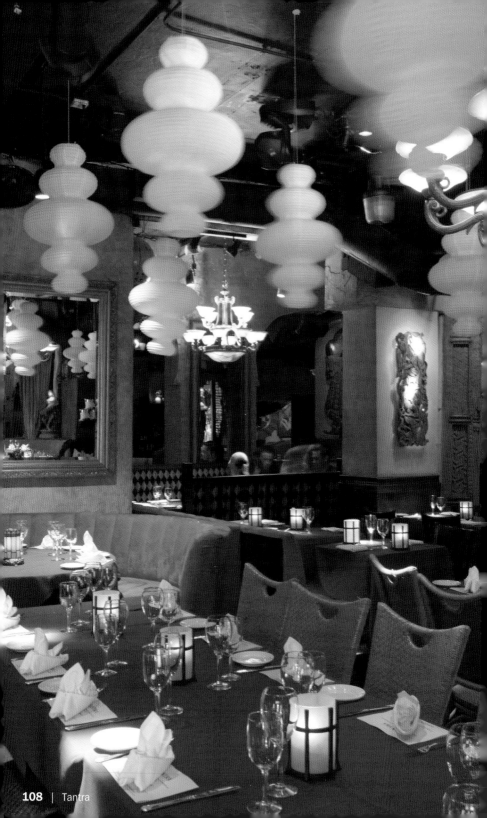

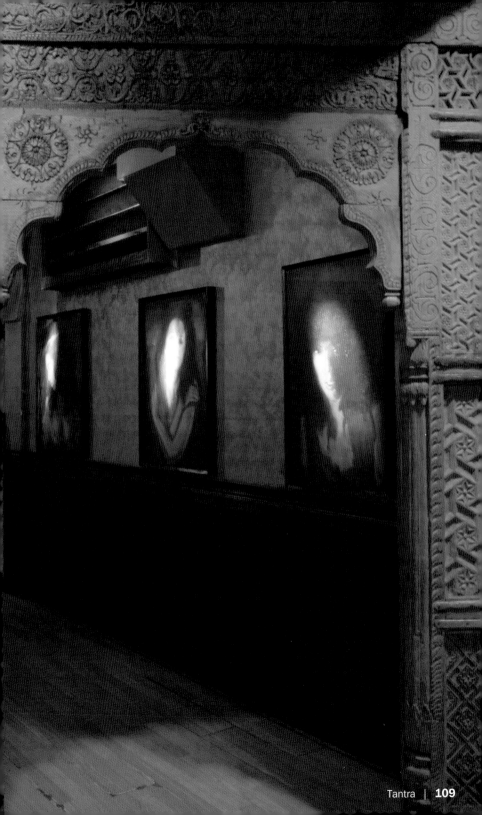

The District

Chef: Servio Lopes | Owners: Ryan & Lowry Brescia, Aramis Lorie, Barbara Basti, Gil Terem

35 NE 40th Street | Miami, FL 33137 | Design District
Phone: +1 305 576 7242
www.thedistrictmiami.com
Opening hours: Lunch Mon–Sat 11:30 am, dinner 5 pm to 11:30 pm
Average price: $ 30
Cuisine: New American
Special features: Outside patio seating, private VIP room

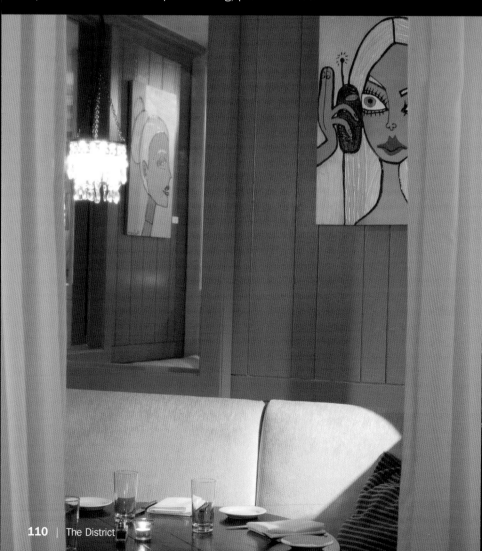

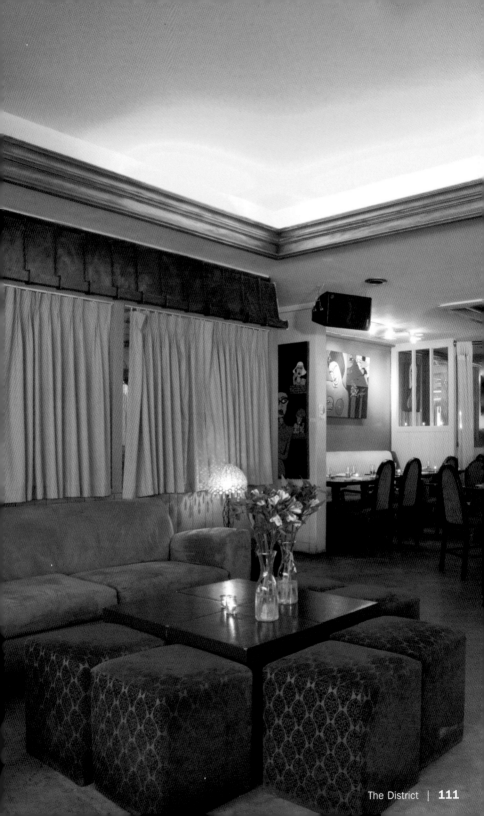

Eggplant Napoleon

Aubergine Napoleon
Aubergine Napoléon
Berenjena Napoleón
Melanzana Napoleon

2 eggplants, cut in 12 slices
2 tomatoes, cut in 8 slices
Fresh mozarella, cut in 8 slices
Fresh herbs (parsley, basil, thyme, rosemary)
Salt, pepper
Olive oil

Marinate the eggplant and tomato slices (separately) with fresh herbs, olive oil, salt and pepper. Grill eggplant and set aside.

For the salsa:
1 small eggplant, diced
1 red chili, chopped
1 red onion, diced
2 spring onions, chopped

Balsamic Vinegar
Salt, pepper, olive oil
Basil for decoration

Sauté all the diced vegetables for 5–10 minutes in olive oil. Season with salt and pepper. Pile eggplant slices, tomato and mozarella to 4 stacks (see illustration). Spoon salsa on top of the stacks. Decorate with fried basil leaves and drizzle with olive oil and balsamic vinegar.

2 Auberginen, in 12 Scheiben
2 Tomaten, in 8 Scheiben
Frischer Mozzarella, in 8 Scheiben
Frische Kräuter (Petersilie, Basilikum, Thymian, Rosmarin)
Salz, Pfeffer
Olivenöl

Die Auberginen- und Tomatenscheiben getrennt mit frischen Kräutern, Olivenöl, Salz und Pfeffer marinieren. Die Aubergine grillen und beiseite stellen.

Salsasauce:
1 kleine Aubergine, gewürfelt
1 rote Chilischote, gehackt
1 rote Zwiebel, gewürfelt
2 Frühlingszwiebeln, gehackt

Aceto Balsamico
Salz, Pfeffer, Olivenöl
Basilikum als Dekoration

Alle gewürfelten Gemüse für 5–10 Minuten in Olivenöl sautieren. Mit Salz und Pfeffer würzen. Aubergine, Tomate und Mozzarella zu 4 Stapeln schichten (siehe Bild). Salsa auf die Stapel geben. Mit frittiertem Basilikum dekorieren und mit Olivenöl und Aceto Balsamico beträufeln.

2 aubergines, en 12 tranches
2 tomates, en 8 tranches
De la mozzarella fraîche, coupée en 8 tranches
Herbes fraîches (persil, basilic, thym, romarin)
Sel, poivre
Huile d'olive

Faire mariner séparément les tranches d'aubergines et de tomates avec les herbes fraîches, l'huile d'olive, le sel et le poivre. Faire griller les aubergines et les mettre de côté.

Sauce salsa:
1 petite aubergine, coupée en dés
1 piment rouge, haché
1 oignon rouge, coupé en dés
2 petits oignons grelots, hachés

Vinaigre balsamique
Sel, poivre, huile d'olive
Du basilic pour la décoration

Faire revenir tous les légumes coupés en dés pendant 5–10 minutes dans l'huile d'olive. Saler et poivrer. Former 4 dômes en superposant les tranches d'aubergine, de tomate et de mozzarella (cf. image). Verser la salsa par-dessus. Décorer de basilic frit et arroser d'huile d'olive et de vinaigre balsamique.

2 berenjenas, en 12 lonchas
2 tomates, en 8 rodajas
Queso mozzarella fresco, en 8 rodajas
Hierbas frescas (perejil, albahaca, tomillo, romero)
Sal, pimienta
Aceite de oliva

Marine las lonchas de berenjena y las rodajas de tomate por separado con las hierbas frescas, el aceite de oliva, la sal y la pimienta. Ase la berenjena a la parrilla y reserve.

Salsa:
1 berenjena pequeña, en dados
1 guindilla roja, picada
1 cebolla roja, en dados
2 cebolletas, picadas

Vinagre balsámico
Sal, pimienta, aceite de oliva
Albahaca para decorar

Saltee todas las verduras en dados en aceite de oliva entre 5–10 minutos. Salpimiente. Haga 4 montoncitos alternando capas de berenjena, tomate y mozarella (véase la imagen). Ponga sobre las torrecitas la salsa. Decórelas con albahaca frita y vierta por encima el aceite de oliva y el vinagre balsámico.

2 melanzane tagliate in 12 rondelle
2 pomodori tagliati in 8 fette
Mozzarella fresca tagliata in 8 fette
Erbe aromatiche fresche (prezzemolo, basilico, timo, rosmarino)
Sale, pepe
Olio d'oliva

Marinate separatamente le fette di melanzane e di pomodoro con le erbe fresche, l'olio d'oliva, il sale e il pepe. Grigliate le melanzane e mettetele da parte.

Salsa:
1 melanzana piccola tagliata a dadini
1 peperoncino rosso tritato
1 cipolla rossa tagliata a dadini
2 cipollotti tritati

Aceto balsamico
Sale, pepe, olio d'oliva
Basilico per decorare

Fate saltare tutte le verdure tagliate a dadini nell'olio d'oliva per 5–10 minuti. Salate e pepate. Formate 4 pile a strati alternati di melanzana, pomodoro e mozzarella (si veda foto). Versate la salsa sulle pile. Decorate con basilico fritto e versatevi alcune gocce di olio d'oliva e aceto balsamico.

The Forge

Design: Al Malnik | Chef: Andrew Swersky
Owner: Shareef Malnik

432 W 41st Street | Miami, FL 33140 | Miami Beach
Phone: +1 305 538 8533
www.theforge.com
Opening hours: Every day 6 pm to open end
Average price: $ 50
Cuisine: Continental
Special features: Famous wine cellar

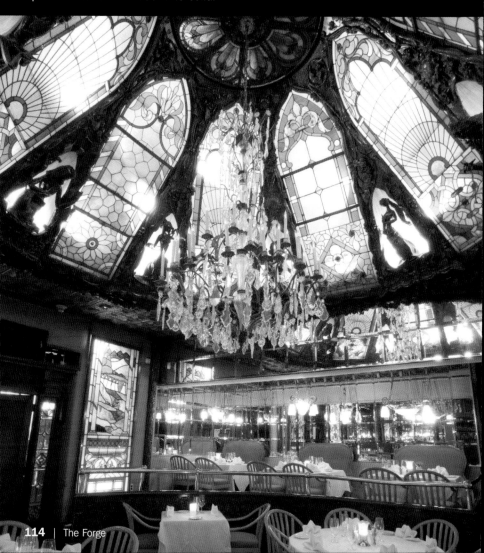

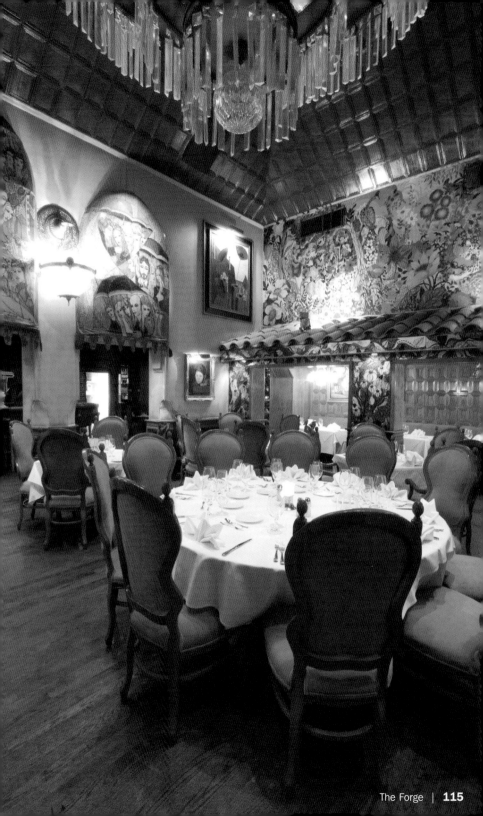

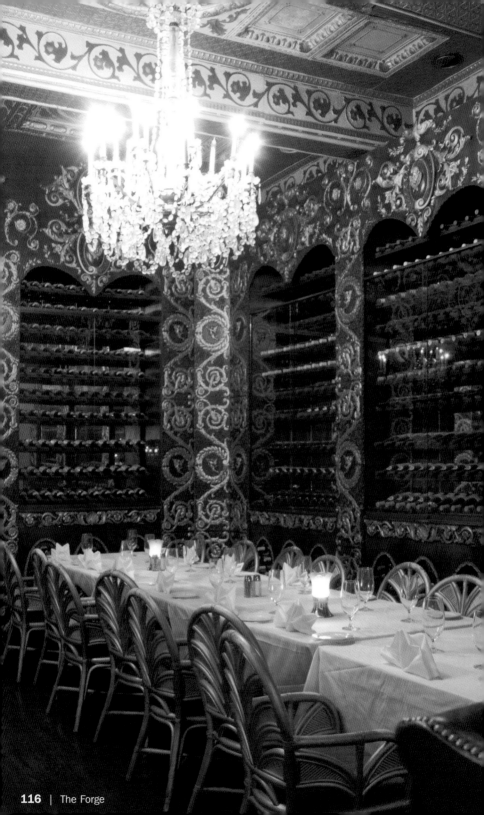

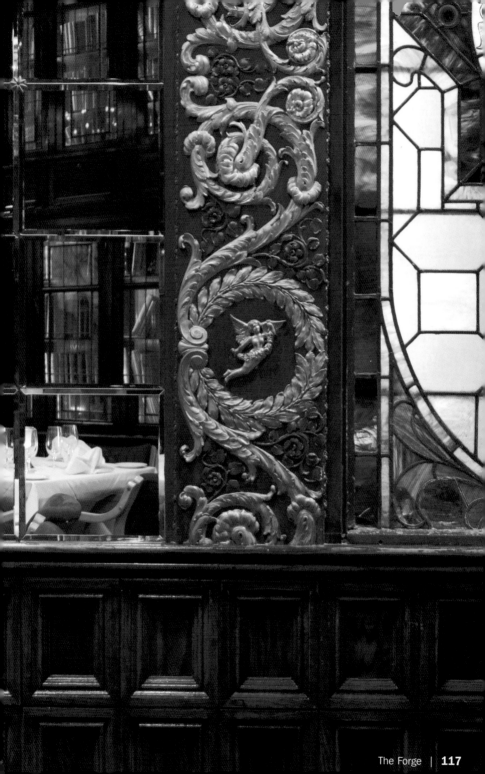

Toni's Sushi Bar

Design: Sam Robin, www.samrobin.com | Chef: Isao Kudo,
Satoru Kimura | Owner: Hiromi Toni Takarada

1208 Washington Avenue | Miami, FL 33139 | South Beach
Phone: +1 305 673 9368
www.tonisushi.com
Opening hours: Sun–Thu 6 pm to midnight, Fri–Sat 6 pm to 1 am
Average price: $ 30
Cuisine: Sushi and Japanese
Special features: Designed as an old samurai house, authentic Japanese atmosphere, seating on the floor

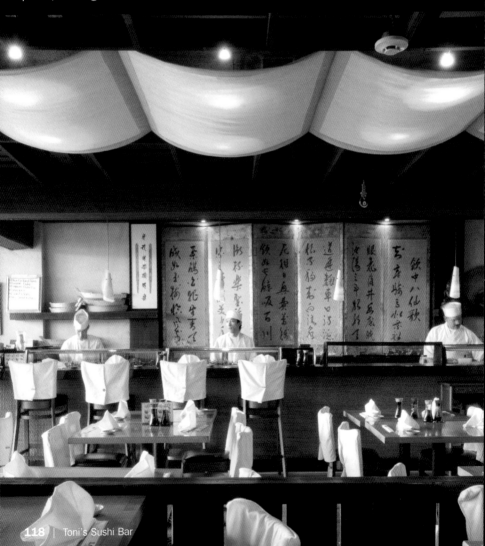

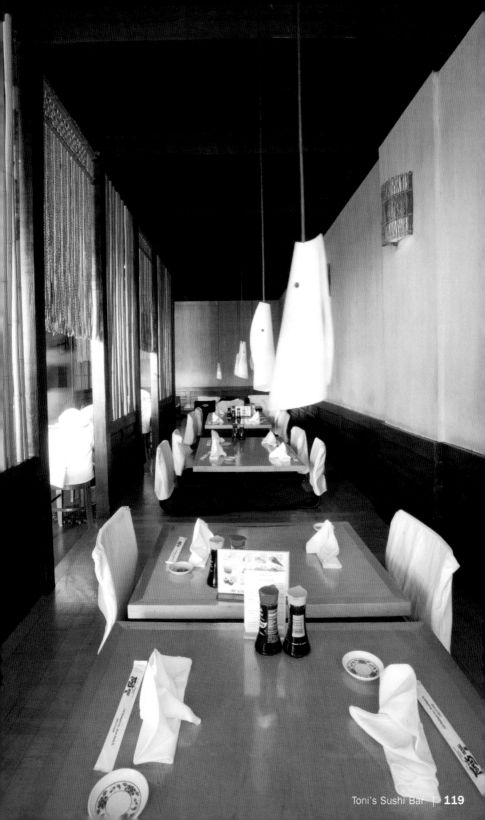

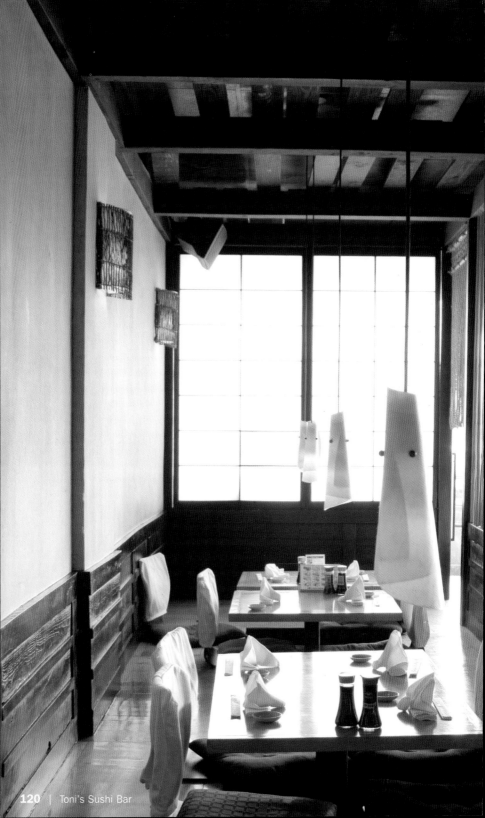

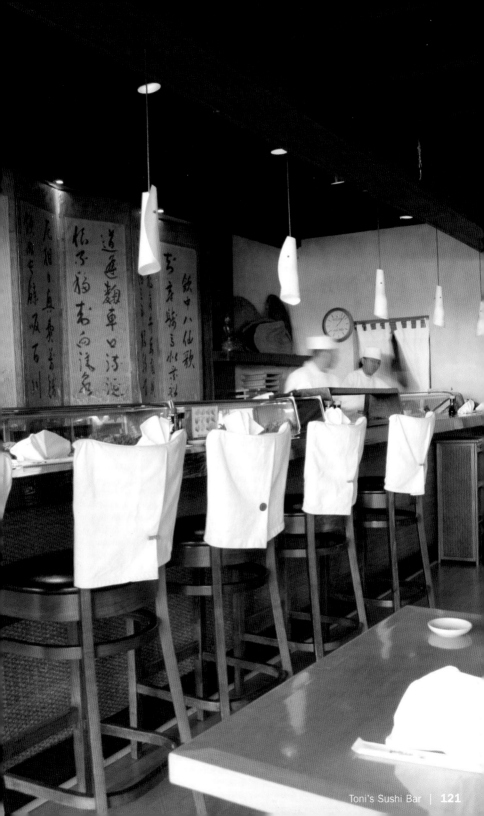

Tuna and Avocado Salad

Thunfisch und Avocado Salat

Salade au thon et à l'avocat

Bonito y ensalada de aguacate

Insalata di tonno e avocado

21 oz fresh tuna, bite-sized pieces
1 ripe avocado, bite-sized pieces

Dressing:
2 oz ginger
1 tbsp Japanese Soya sauce
1 tbsp rice vinegar
1 tbsp water
1 tsp tomato ketchup
1 tsp sesame oil
Salt, pepper
Lettuce, lemon, fresh cress for decoration

Mix all dressing ingredients in a blender until smooth. Combine tuna and avocado in a bowl and mix with dressing. Garnish with lettuce, lemon and fresh cress.

600 g frischen Thunfisch, in mundgerechten Stücken
1 reife Avocado, in mundgerechten Stücken

Vinaigrette:
60 g Ingwerwurzel
1 EL japanische Sojasauce
1 EL Reisessig
1 EL Wasser
1 TL Tomatenketchup
1 TL Sesamöl
Salz, Pfeffer
Salat, Zitrone und frische Kresse zum Garnieren

Alle Vinaigrettezutaten in einem Mixer glatt mixen. Thunfisch und Avocado in eine Schüssel geben und mit der Vinaigrette mischen. Mit Salat, Zitrone und frischer Kresse garnieren.

600 g de thon frais, en petits morceaux
1 avocat mûr, en petits morceaux
Vinaigrette:
60 g de racines de gingembre
1 c. à soupe de sauce soja japonaise
1 c. à soupe de vinaigre de riz
1 c. à soupe d'eau
1 c. à café de ketchup à la tomate
1 c. à café d'huile de sésame
Sel, poivre
Salade, citron et cresson frais pour la garniture

Bien mélanger dans un mixer tous les ingrédients de la vinaigrette. Mettre le thon et l'avocat dans un récipient et mélanger à la vinaigrette. Garnir avec la salade, le citron et le cresson frais.

600 g de bonito fresco, troceado en bocados
1 aguacate maduro, troceado en bocados
Vinagreta:
60 g de raíz de jengibre
1 cucharada de salsa de soja japonesa
1 cucharada de vinagre de arroz
1 cucharada de agua
1 cucharadita de ketchup
1 cucharadita de aceite de sésamo
Sal, pimienta
Lechuga, limón y berros frescos para decorar

Triture todos los ingredientes de la vinagreta en un robot de cocina hasta conseguir una mezcla homogénea. Ponga el bonito y el aguacate en un cuenco y mézclelos con la vinagreta. Decore con lechuga, el limón y los berros frescos.

600 g di tonno fresco a bocconcini
1 avocado maturo a bocconcini
Vinaigrette:
60 g di radice di zenzero
1 cucchiaio di salsa di soia giapponese
1 cucchiaio di aceto di riso
1 cucchiaio di acqua
1 cucchiaino di ketchup
1 cucchiaino di olio di sesamo
Sale, pepe
Insalata, limone e crescione fresco per guarnire

In un frullatore frullate bene tutti gli ingredienti per la vinaigrette. Mettete in una ciotola il tonno e l'avocado e aggiungetevi la vinaigrette. Guarnite con insalata, limone e crescione fresco.

Touch Restaurant

Design: Stephane Dupoux | Chef: Sean Brasel
Owner: David Tornek

910 Lincoln Road | Miami, FL33139 | South Beach
Phone: +1 305 532 8003
www.touchrestaurant.com
Opening hours: Sun–Thu 7 pm to midnight, lounge to 2 am, Fri–Sat 7 pm to 2 am,
lounge to 4 am
Average price: $ 28
Cuisine: Modern influenced grill
Special features: Special events, Brazilian night, fashion show

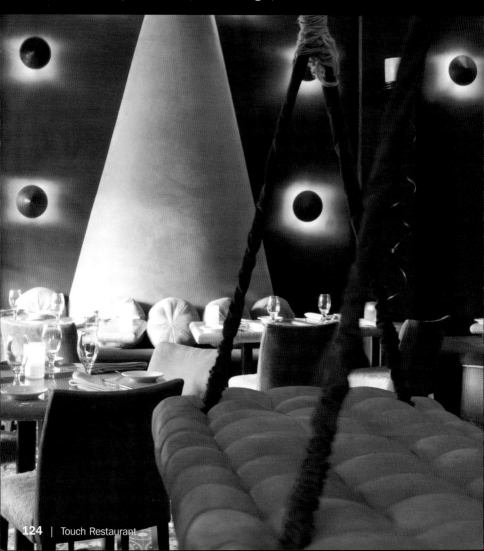

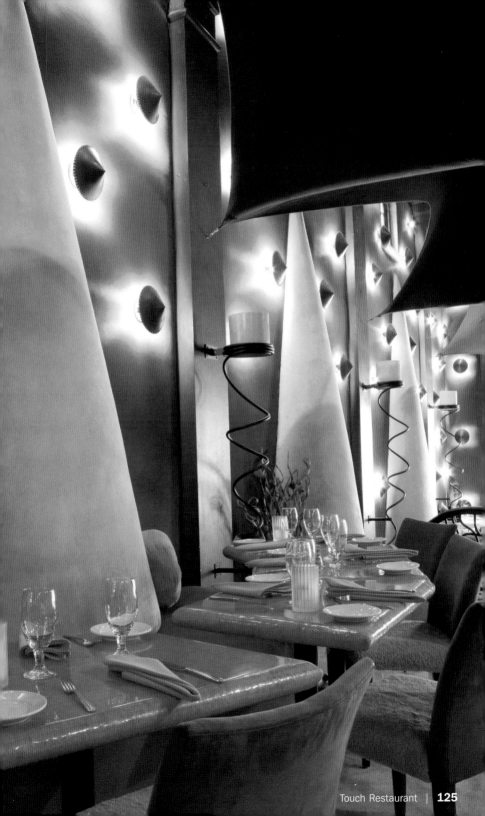

Vita

Design: Franchisqua | Chef: Luciano Sautto | Owner: Roberto Caan

1906 Collins Avenue | Miami, FL 33139 | South Beach
Phone: +1 305 538 7855
www.vita-restaurant.com
Opening hours: Mon–Thu 7 pm to midnight, Fri–Sat 7 pm to 1 am
Average price: $ 32
Cuisine: Northern Italian
Special features: Outdoor seating in garden area

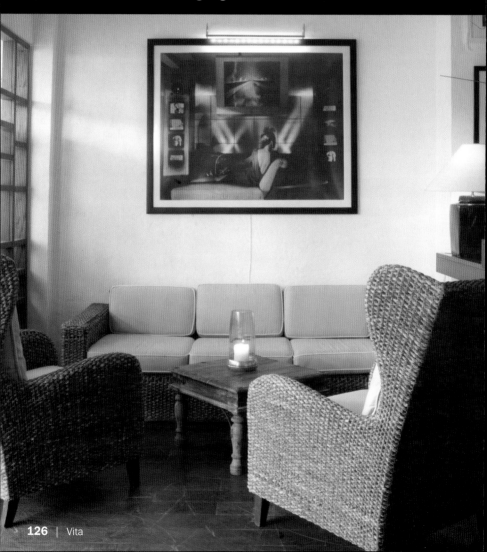

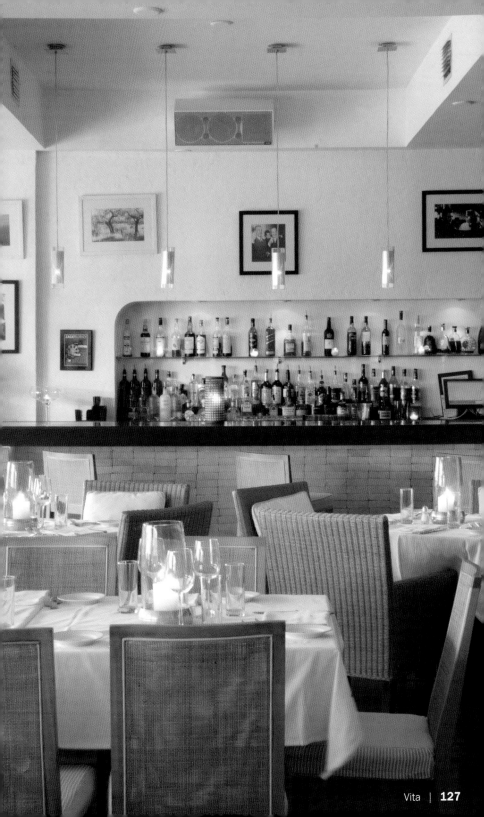

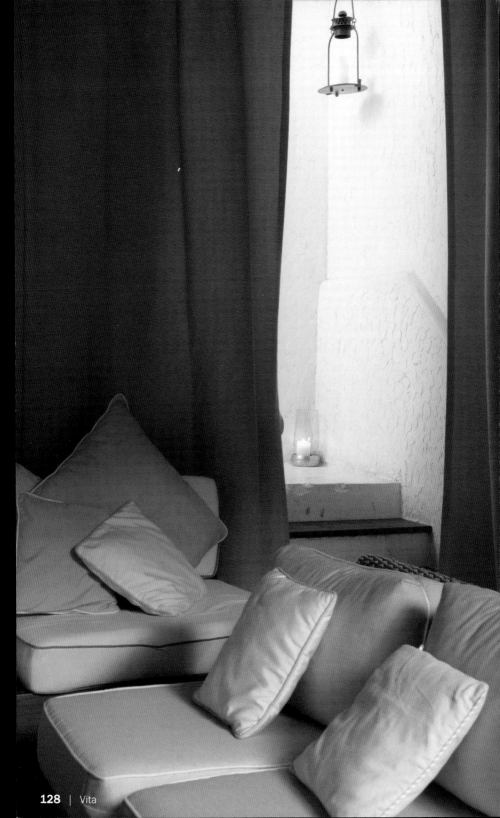

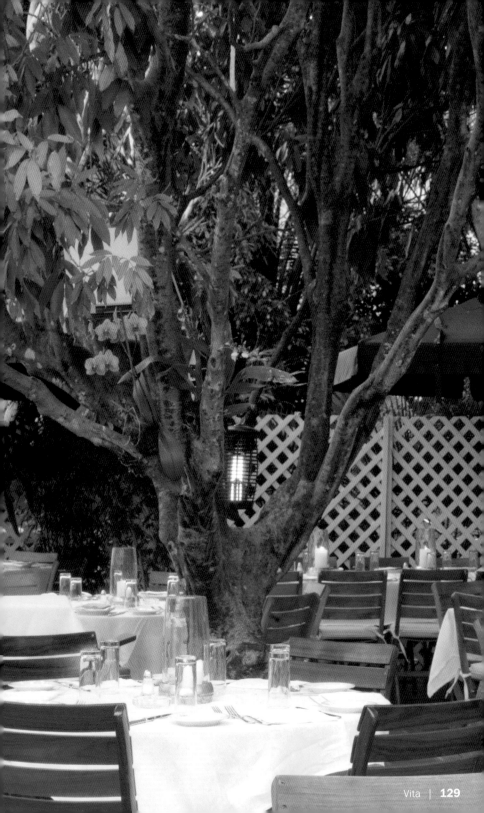

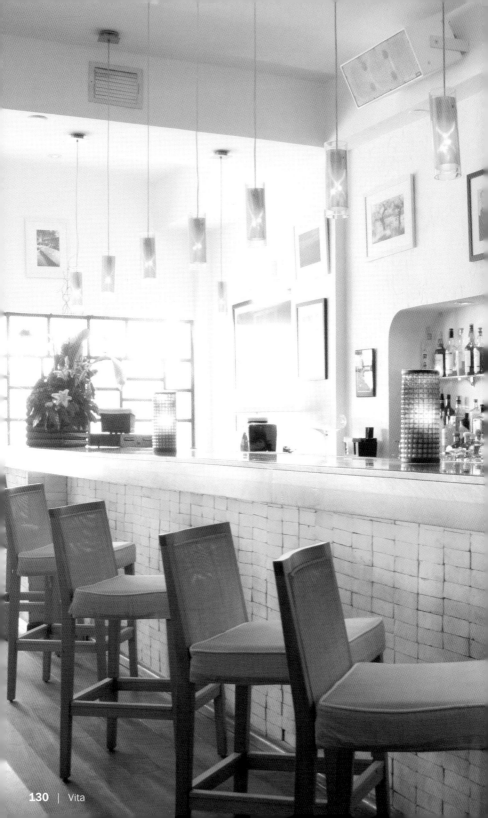

VIX

Design: Jacques Garcia | Chef: James Wierzelewski
Owner: ZOM USA

1144 Ocean Drive | Miami, FL 33139 | South Beach
Phone: +1 305 779 8888
www.hotelvictorsouthbeach.com
Opening hours: Breakfast 7 am to 11 am, lunch noon to 3 pm, dinner 7 pm to midnight
Average price: $ 33
Cuisine: International
Special features: Outdoor/ indoor seating overlooks Ocean Drive, 500 gallon jellyfish
tank, exhibition kitchen, circular bar

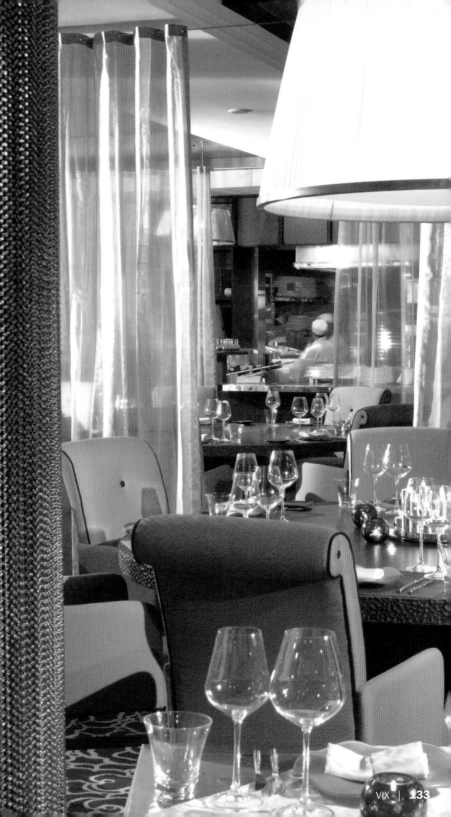

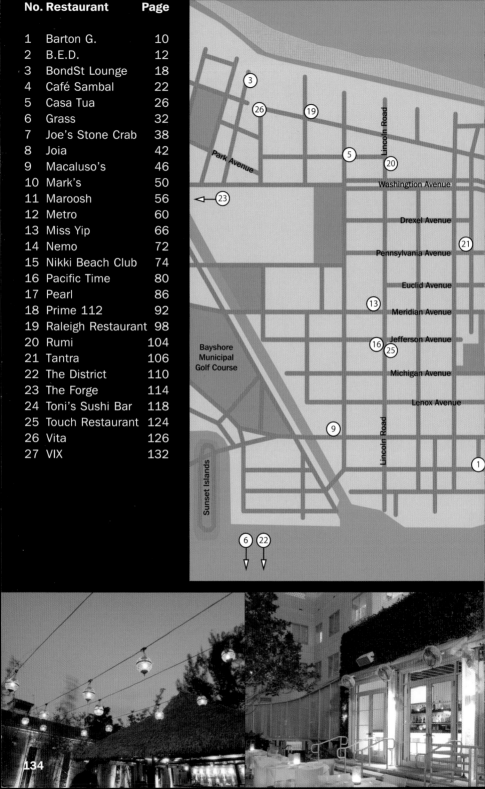

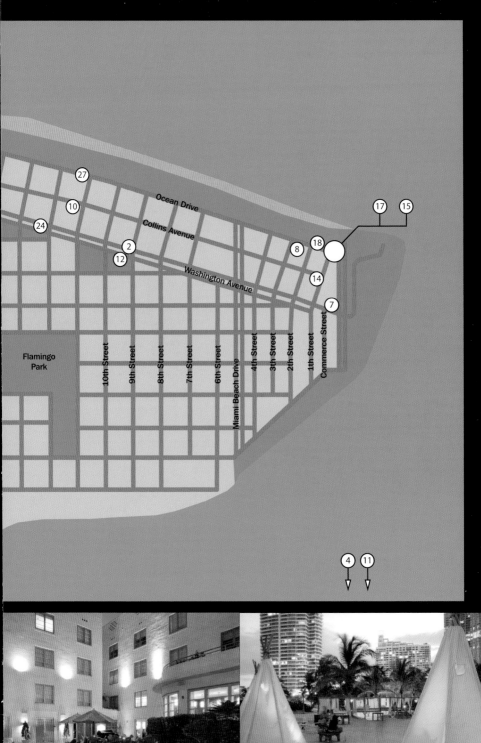

Ocean Drive

Collins Avenue

Washington Avenue

27

10

24

2

12

8

18

14

7

17 15

Flamingo Park

10th Street
9th Street
8th Street
7th Street
6th Street
Miami Beach Drive
4th Street
3th Street
2th Street
1th Street
Commerce Street

4 11

Cool Restaurants

Size: 14 x 21.5 cm / 5 $\frac{1}{2}$ x 8 $\frac{1}{2}$ in.
136 pp
Flexicover
c. 130 color photographs
Text in English, German, French,
Spanish and (*) Italian / (**) Dutch

Other titles in the same series:

Amsterdam (*)
ISBN 3-8238-4588-8

Barcelona (*)
ISBN 3-8238-4586-1

Berlin (*)
ISBN 3-8238-4585-3

Brussels (**)
ISBN 3-8327-9065-9

Chicago (*)
ISBN 3-8327-9018-7

Côte d' Azur (*)
ISBN 3-8327-9040-3

Hamburg (*)
ISBN 3-8238-4599-3

London
ISBN 3-8238-4568-3

Los Angeles (*)
ISBN 3-8238-4589-6

Madrid (*)
ISBN 3-8327-9029-2

Milan (*)
ISBN 3-8238-4587-X

Munich (*)
ISBN 3-8327-9019-5

New York
ISBN 3-8238-4571-3

Paris
ISBN 3-8238-4570-5

Prague (*)
ISBN 3-8327-9068-3

Rome (*)
ISBN 3-8327-9028-4

San Francisco (*)
ISBN 3-8327-9067-5

Shanghai (*)
ISBN 3-8327-9050-0

Sydney (*)
ISBN 3-8327-9027-6

Tokyo (*)
ISBN 3-8238-4590-X

Vienna (*)
ISBN 3-8327-9020-9

Zurich (*)
ISBN 3-8327-9069-1

To be published in the same series:

Cape Town
Copenhagen
Dubai
Geneva
Hong Kong
Ibiza/Majorca
Istanbul

Las Vegas
Mexico City
Moscow
Singapore
Stockholm
Tuscany

teNeues